American Handweaving Museum - F12
Antique Boat Museum - F12
Arthur Child Heritage Center - B12
Bensons Rift - D17
Boldt Castle - E18
Brockville Museum - A28
Cape Vincent Fisheries Aquarium - F5
Cornwall Bros. Store - E18
Crossover Island Light - B24
Darlingside - C18
Devil's Oven - E18
Fiddler's Elbow - C17
Fort Frederick R.M.C. Museum - A4
Fort Henry - A4
Fort Haldimand - E6

Frederic Remington Studio - C23
Fulford Place - A29
Half Moon Bay - C12
Indian Star Rock Painting - D19
International Rift - D17
LaRue Mills - C21
Lost Channel - C17
Lover's Lane - C16
Maclachlan Woodworking Museum - A8
Marine Museum of the Great Lakes - A3
Millionaire's Row - E18
Minna Anthony Nature Center - E15
Molly's Gut - A26
Murney Tower Museum - A3
Needles Eye - D16

Potters Beach - D12
Rock Island Light - F15
Singer Castle - C23
Sister Island Light - D21
Skydeck - D17
Steam Museum - A3
Sunken Rock Light - E18
Tibbetts Point Light - F3
Thousand Islands Club - E18
Thousand Islands Museum - F12
Thousand Islands Playhouse - B13
Tom Thumb Island - C17
Wanderer's Channel - C11

Map continues inside rear cover

Willowbank
Firmans Point
Ferry Route
Gillespies Point
Bishops Pt.
Beaurivage I.
McDonald I.
Lindsay I.
Aubrey I.
Mermaid I.
Bostwick I.
Admiralty Islands
Gananoque
Thousand Islands Playhouse
Arthur Child Heritage Center
Tremont Park I.
Hay I.
Half Moon Bay
Grays Beach
Sturdivants Point
Halsteads Bay
Landons Bay
Navy Islands
Gordon I.
Lover's Lane
Ivy Lea
Smugglers Cove
Ivy Lea Park
Fiddler's Elbow
Canadian Span
Darlingside Palisades
Georgina I.
Constance I.
Club I.
Bensons Rift
Skydeck
Ash I.
Lost Channel
Tom Thumb I.
Needles Eye
Mulcaster I.
Downie I.
Stave I.
Thwartway I.
Forty Acre Shoal
Lake Fleet Islands
Sugar I.
Prince Regent I.
Camelot I.
Endymion I.
Watterson Pt. State Park
Wellesley Island State Park
International Rift
Hill Island
St. Lawrence River
Thurso
Potters Beach
Grandview Park
Canoe Point State Park
Picnic Point State Park
Eel Bay
Dewolf Pt. State Park
Lake of the Isles
Boldt Yacht House
Westminster Park
Thousand Islands Golf Club
Thousand Islands Club
Hickory Island
Quebec Head
Beauvais Point
Grindstone Island
Wellesley Island
Densmore Bay
Flynn Bay
Cummings Point
Aunt Janes Bay
Grossman Point
Rusho Bay
Picton I.
Murray I.
Minna Anthony Nature Center
American Span
Brown Bay
Moores Landing
Swan Bay
Devil's Oven
Cornwall Bros. Store
Millionaire's Row
Bluff I.
Maple I.
Grenell I.
South Bay
Thousand Island Park
Fineview
Collins Landing
Point Vivian
Keewaydin State Park
Alexandria Bay
St. Lawrence River
Pine I.
Calumet I.
Bartlett Point
French Creek Bay
Washington I.
Round I.
Spicer Bay
Upper Narrows
St. Lawrence Park
New York
Antique Boat Museum
French Creek
Clayton
Thousand Islands Museum
Carrier Bay
American Handweaving Museum
Blind Bay
Fishers Landing
Grass Point State Park
Mullet Creek Bay
Rock Island Light State Park

Bush Bay
Wanderers Channel

Parks in Canada
Parks in the U.S.
Lighthouses
Seaway Trail

The 1000 Islands

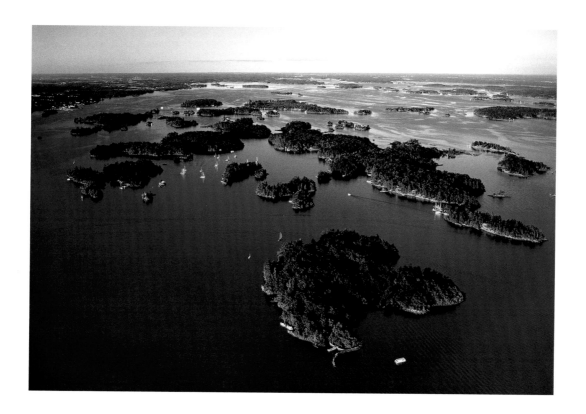

Ian Coristine

Acknowledgements

This book has been in my mind's eye since my first summer in the Islands, gradually coming into focus and reality over time. By no means has it been a solo effort, as I have received a tremendous amount of encouragement and help from a great many people. It would take far more space than is available here to detail everyone and all of their contributions, but I would like to specifically thank; Joan & Bo Collins, Hayley Coristine, Mary Coristine, Scotty Coristine, Kathy & Dudley Danielson, Elizabeth Fee, Michael Flahault, Dave Griffith, Carl Hiebert, Michael Keyser, Roger Lucas, Scott MacCrimmon, Paul Malo, Joan Michie, Ken Robinson, Paul Rupert, Don Ross, Shane Sanford, Paul Sicard, Susan Smith and Victoria Thorburn. I must single out Michael Keyser. It took me years of exploring to search out many of the "secret places" of the 1000 Islands. Thanks to Michael's intensive efforts in helping me create the map, it won't take you nearly as long.

Prints of the images are available

Each of the images in this book (and others from the author's library) including the map of the islands, is available as an art print suitable for framing. Each print is reproduced on premium paper and signed by the artist. These prints and others of the 1000 Islands are available at selected gift shops and galleries in the area, or they can be ordered via the Internet at: http://www.1000islandsphotoart.com. Please leave your email address at the web site if you wish to be notified as new items become available.

National Library of Canada Cataloguing in Publication Data

Coristine, Ian, 1949-
The Thousand Islands : Ian Coristine

ISBN 0-9730419-1-9

1. Thousand Islands (N.Y. and Ont.)—Aerial photographs.
2. Landscape photography—1000 Islands (N.Y. and Ont.)
I. Title.

FC3095.T43C67 2002 917.13'7 C2002-900619-8
F1059.T48C67 2002

Published by:
1000 Islands Photo Art
http://www.1000islandsphotoart.com
3rd (revised) printing

Copyright © Ian Coristine

Printed in Canada

Introduction

I was here once as a very young child, but the only memory that remains from that early visit is a toddler's fascination with fish swimming inside a boathouse. It was almost forty years before I returned.

My business has been the distribution of Challenger recreational aircraft in Canada. In 1990, I purchased a set of floats for my plane and that summer set off on a mini-adventure vacation with two friends, each of us flying our own plane. The intent, now that we were "boat" owners, was to explore some of eastern Canada's waterways, of which I knew very little. We saw many lovely sights along the river heading west from my home near Montreal, but at Brockville the character of the river changed dramatically.

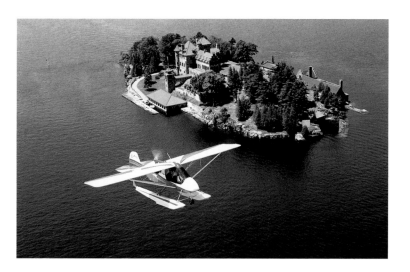

By the time we reached the 1000 Islands Bridge, I was simply amazed. The more we explored, the more profound the experience. It was a day of wonder, rich in wildlife and natural beauty, while shipwrecks in the shallows and grand old cottages and castles suggested a fascinating history.

Five years later, a small island with its own unique natural harbor that could provide protection for my plane became our family's summer home. It was offered for sale just once in the 20th century, and it was our very good fortune to become its owners.

It mystifies me that, like a great many others, I had lived within an easy drive of the area, yet had never realized just what wonders were here. The more I have explored, the more entranced I have become. My photography began simply as an attempt to show friends what I had "discovered", and at over 200 square miles, there is a lot to discover. It is extensive enough and has such diversity that it is difficult even for people who have lived here all their lives to know it all.

My plane has given me the means to explore much more of it than I could by boat, both in terms of area and in getting my camera and me to places where boats cannot go. It has also given me a very different perspective that is not just of the next shoreline or island, but a bird's eye view of the world's most beautiful and intricate labyrinth. This book has evolved as a desire to share with others the privileged view that I have been so fortunate to enjoy. I hope you enjoy it too.

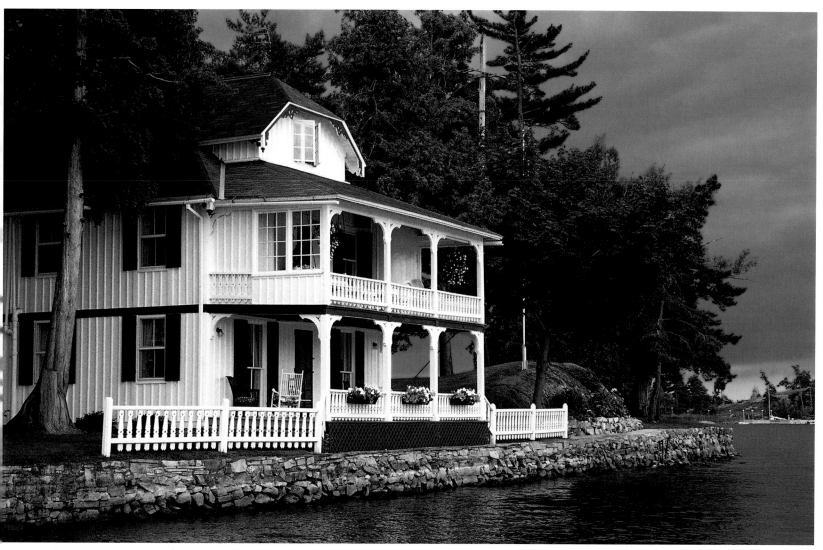

Cottage owners in the 1000 Islands have traditionally taken great pride in creating and maintaining summer homes that enrich the unique beauty of the area. Manhattan Island's Hasbrouck House has lent its charms for over a century.

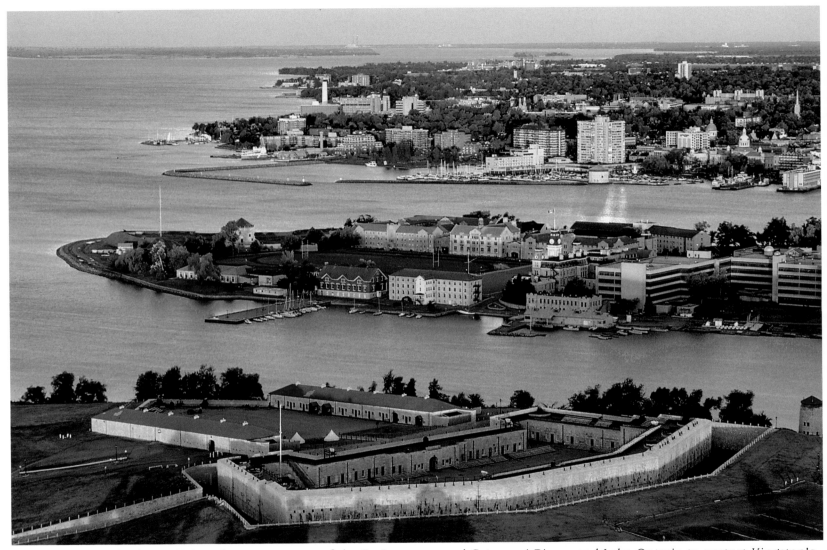

Fort Henry was built in 1832 at the convergence of the St. Lawrence and Cataraqui Rivers and Lake Ontario to protect Kingston's dockyards. Royal Military College (Canada's West Point) occupies the middle peninsula with Kingston across the Cataraqui beyond.

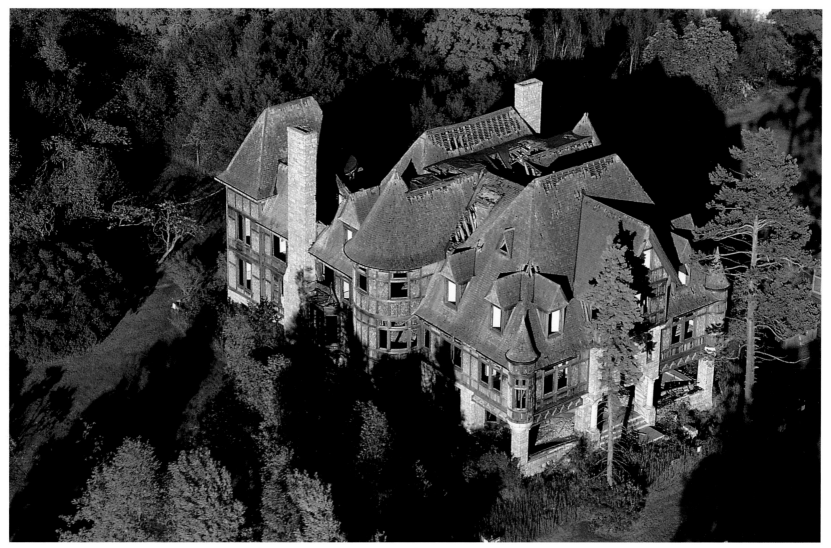

In the 1890s, the grandest summer palace on the river was Carleton Villa, built by Remington (Arms and Typewriter) marketing whiz, W. O. Wyckoff. Thanks to the efforts of the 1000 Islands Bridge Authority, Boldt Castle barely escaped a similar fate.

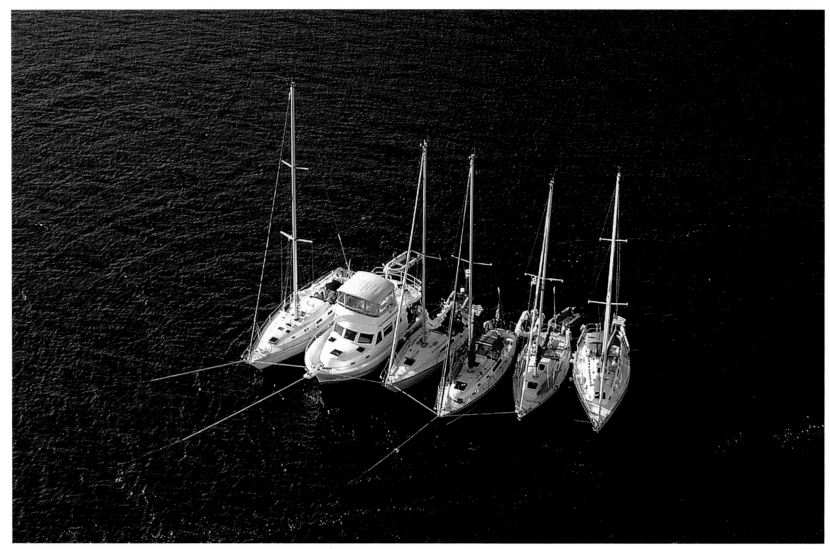

Odd man in. A Saturday evening gathering of friends in South Bay at the west end of Carleton Island, near Cape Vincent.

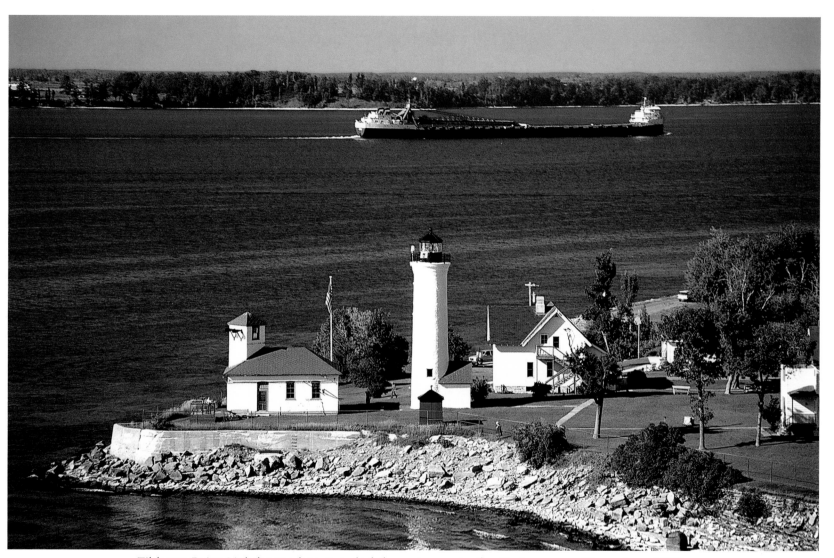

Tibbetts Point Lighthouse has guarded the entrance to the St. Lawrence River since 1827.
The square tower houses two steam foghorns. Locals are delighted they are no longer used!

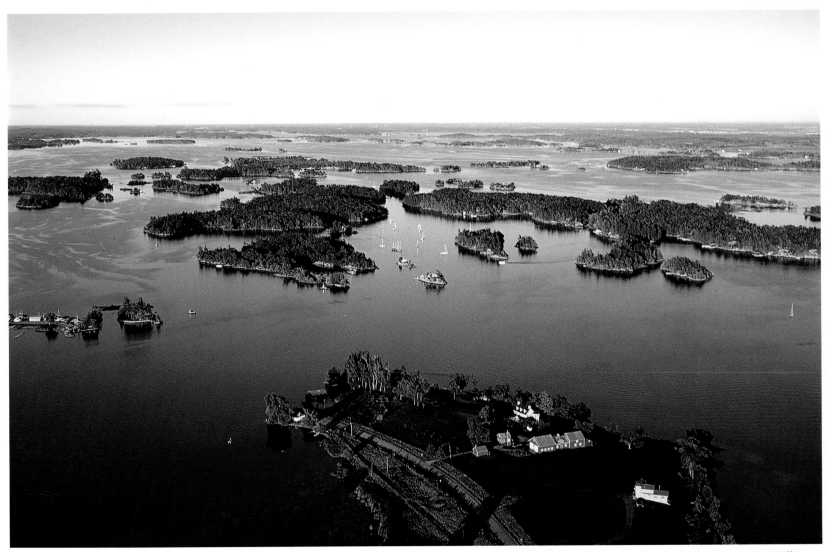

A cable ferry connects Howe Island's eastern tip to the mainland just upstream of the Admiralty Islands. In 1816, Captain William Fitzwilliam Owen named these islands after Admirals of the British Navy, doing his naval career no harm in the process.

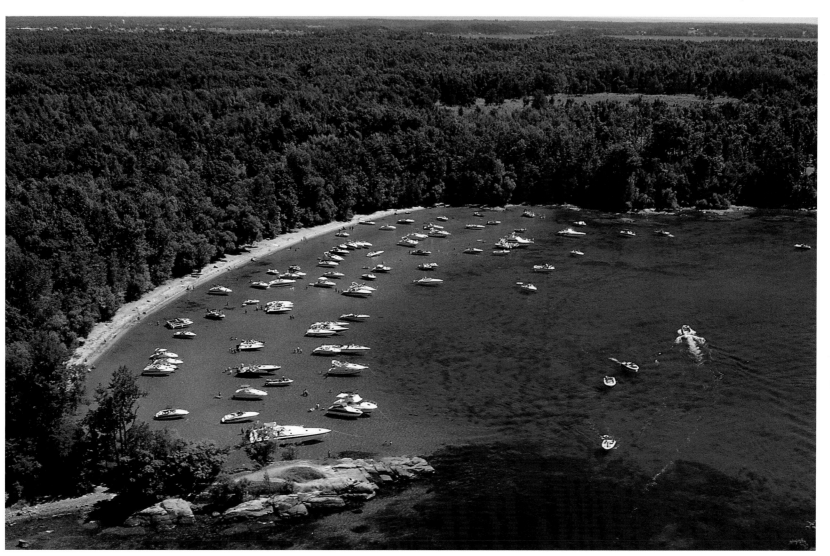

There are a great many places to enjoy the river, but not many beaches. Potter's Beach on Grindstone Island is the powerboat anchorage of choice, protected forever under the ownership of the Thousand Islands Land Trust.

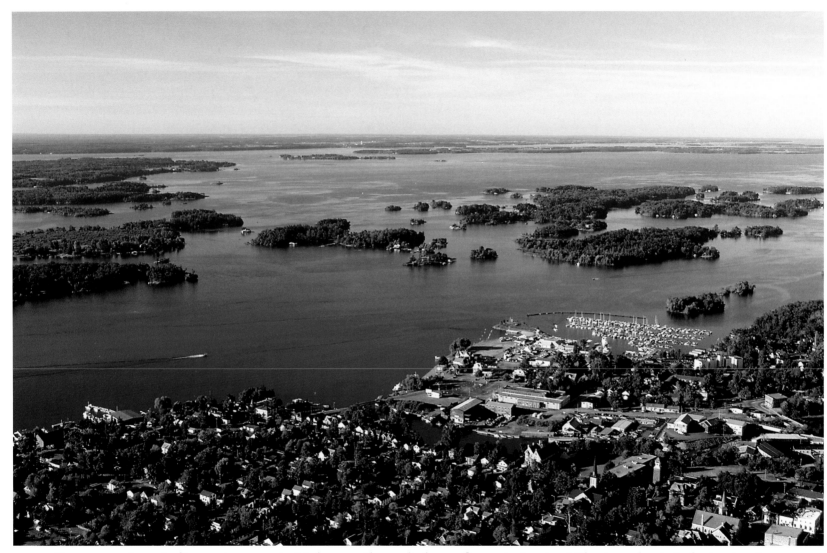

Gananoque is an Indian name meaning "place on the rocks by swift moving water." The town hosts industry, tourism, and a large seasonal boating community. It sits on land granted in 1792 to Colonel Joel Stone, a United Empire Loyalist.

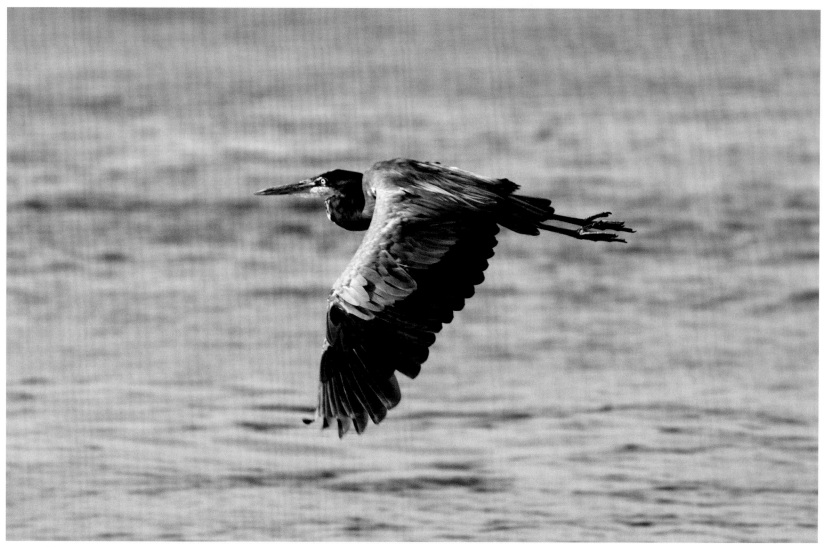

Great blue herons are very much an icon of the 1000 Islands. My children learned the hard way that they feed day and night after the fish they released into a small pond on our island one evening had mysteriously vanished by the next morning.

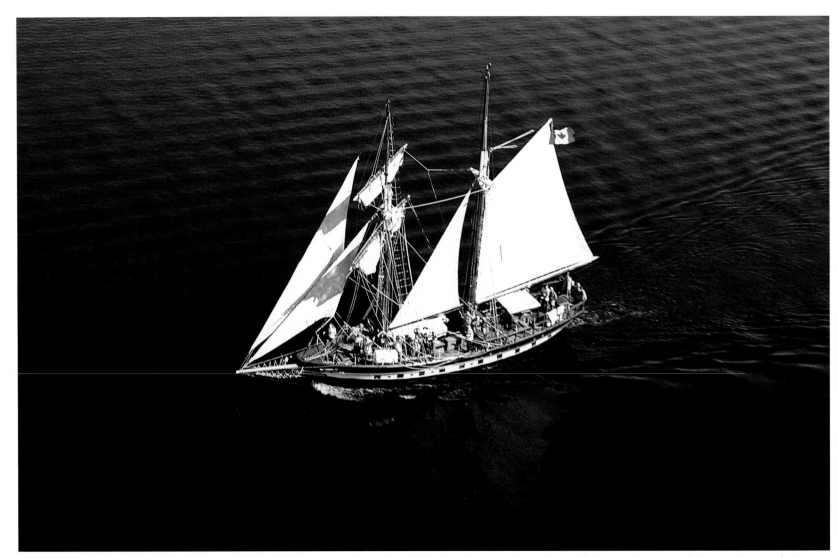

The training brigantine St. Lawrence II makes me wonder about all who have passed through here. Since prehistoric times this was the route to the center of the continent, where much of the history of Canada, the U.S., and the Indian Nations played out.

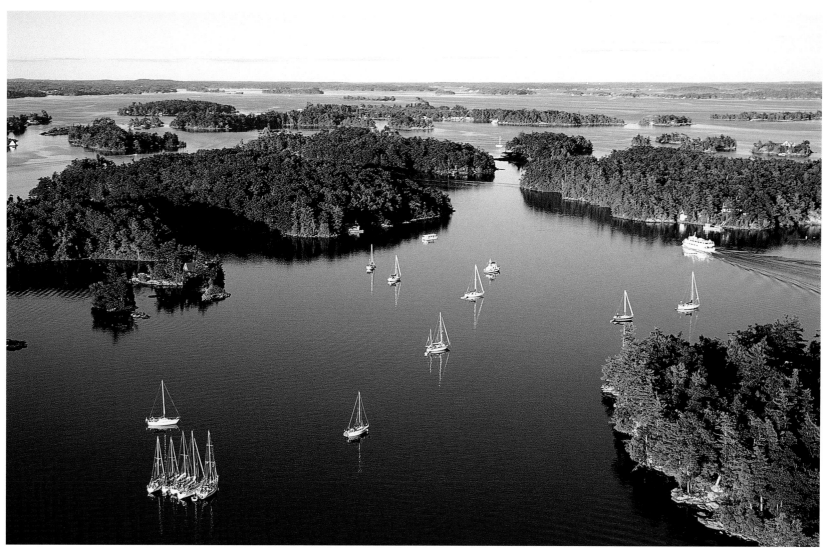

Contrary to the name, there are over 1800 islands in the 1000 Islands, with roughly two thirds of them in Canada. They are divided fairly equally in terms of area, however, as negotiated in an agreement signed in 1822.

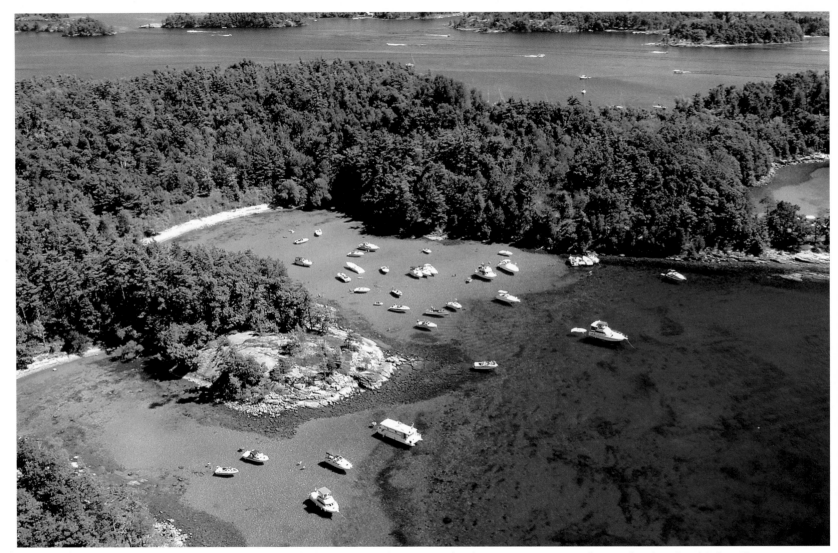

In 1816, William Owen named this island Thwart Way. In 1873, Charles Unwin renamed it Leek Island, which still appears on charts. Parks Canada finally chose the original name, but as a single word. Somehow, these boaters found it anyway!

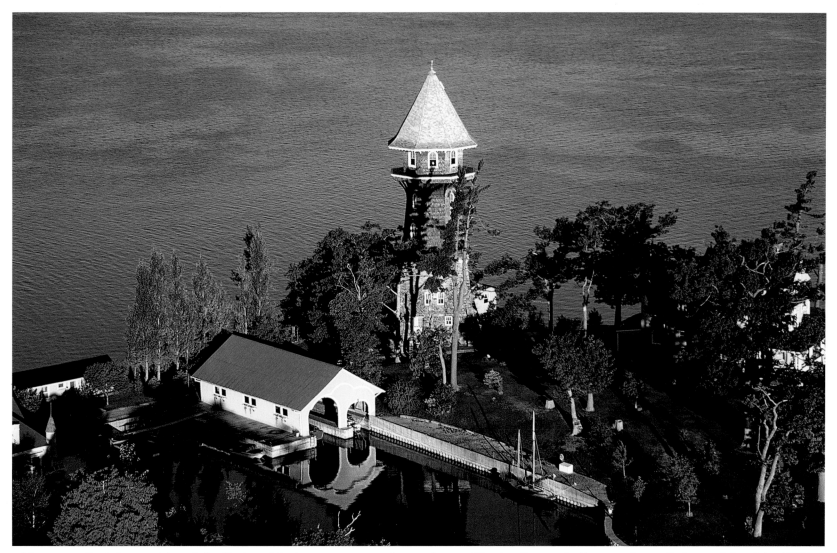

After traveling the world and finding nothing to compare, tobacco baron Charles Emery built a castle on Calumet Island in 1893. Intended for future generations, the castle sat unused for half a century, eventually burning in 1957. Only its water tower remains.

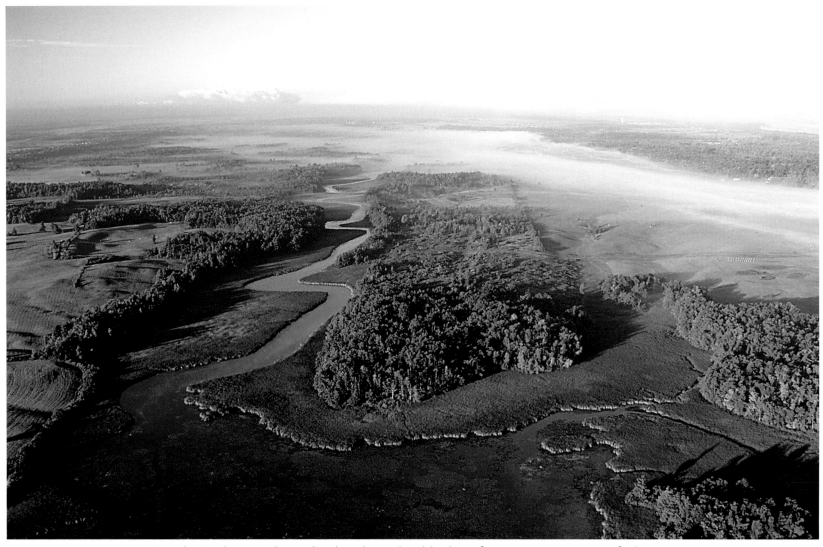

French Creek meanders inland under a thin blanket of morning mist west of Clayton,
providing habitat for many wetland species as well as spawning grounds for fish.

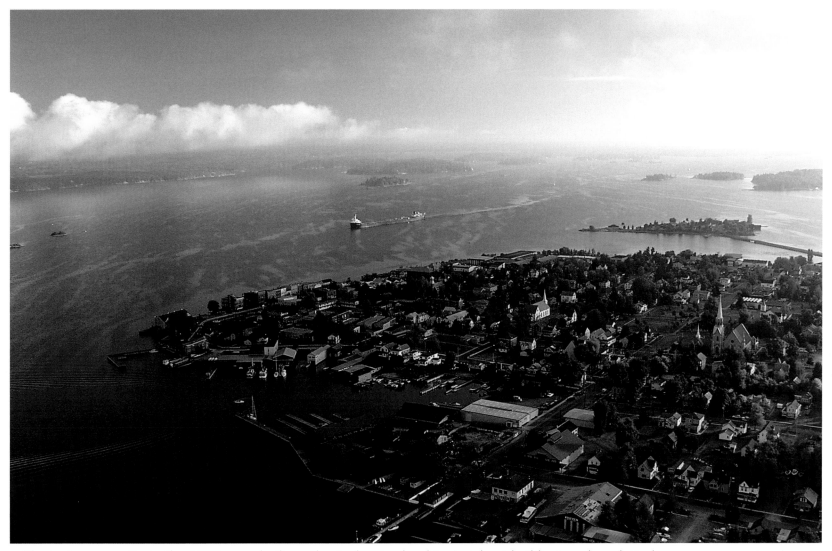

Clayton's prosperity in the 1800s was built on the timber trade, shipping, boat building, and a relatively new resource: tourism. As the 20th century dawned, Clayton was one of the most famous resort destinations in the U.S.

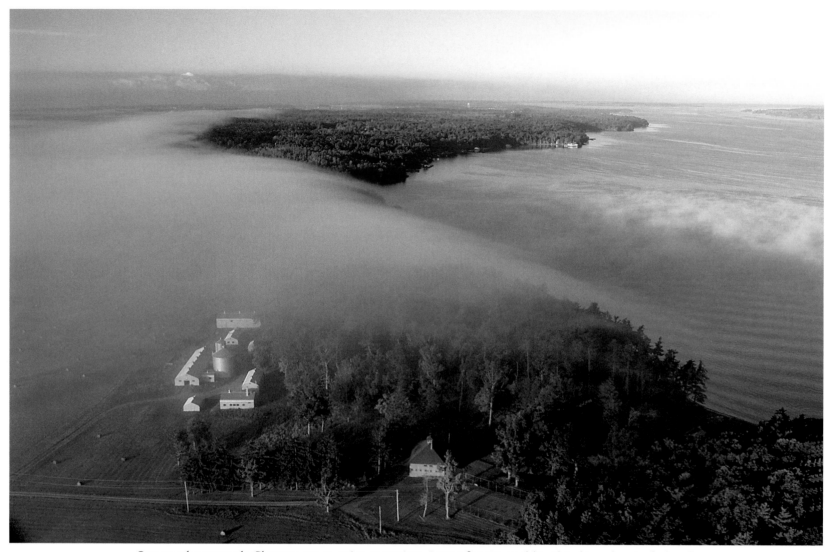

Out to photograph Clayton on a quiet morning, I was fascinated by this low sheet of cloud, cascading over the shoreline just west of Bartlett Point and French Creek Bay.

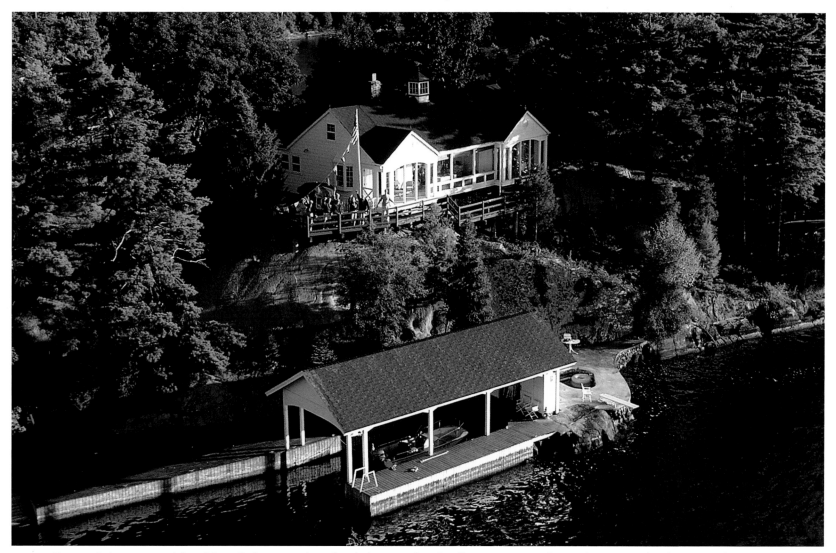

Entertaining on an island is a little more involved than on land. All groceries and supplies come by boat, as do guests, who need to be met and provided with accommodation for the night or another boat ride back to shore.

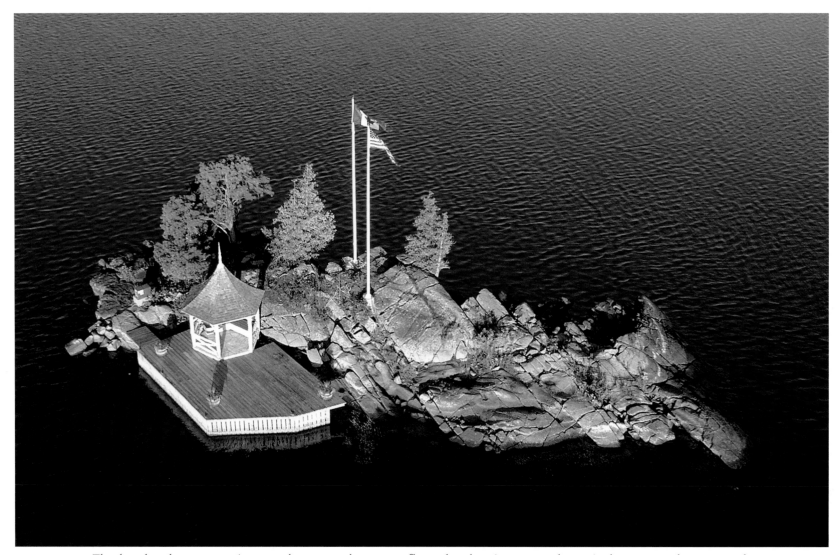

The border does not quite pass between these two flagpoles, but in many places it does pass close enough between American and Canadian islanders for them to be within speaking distance of one another.

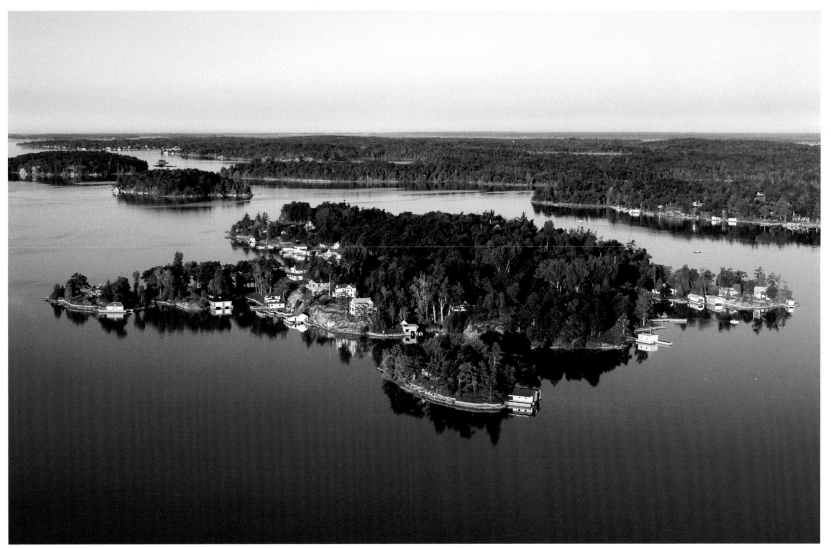

Grenell Island is one of many island cottage communities on the river where family friendships go back generations. Each is a treasured world unto itself within a greater wonderland.

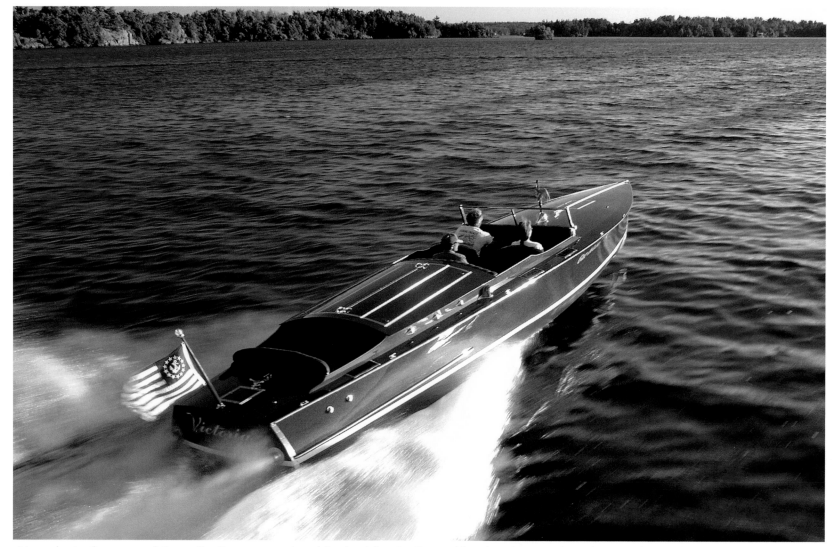

Many lovingly restored "woodies" are operational in the islands. Some, like this Garwood, with a mother-in-law cockpit at the rear, have modern engines that make them surprisingly fast. For devotees, the Antique Boat Museum in Clayton is a must.

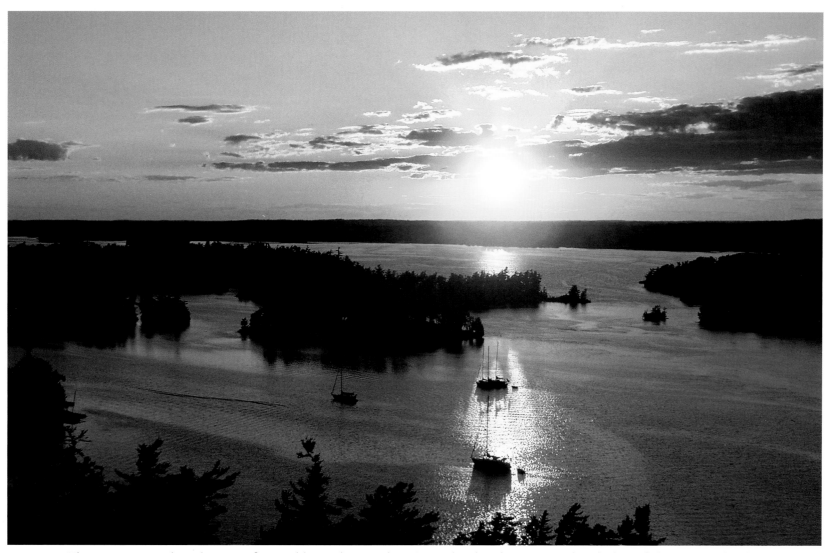

There are several anchorages favored by sailors in the 1000 Islands. This one, in the shelter of the Navy Islands, seldom sees the sun set without at least a few masts as part of the scene.

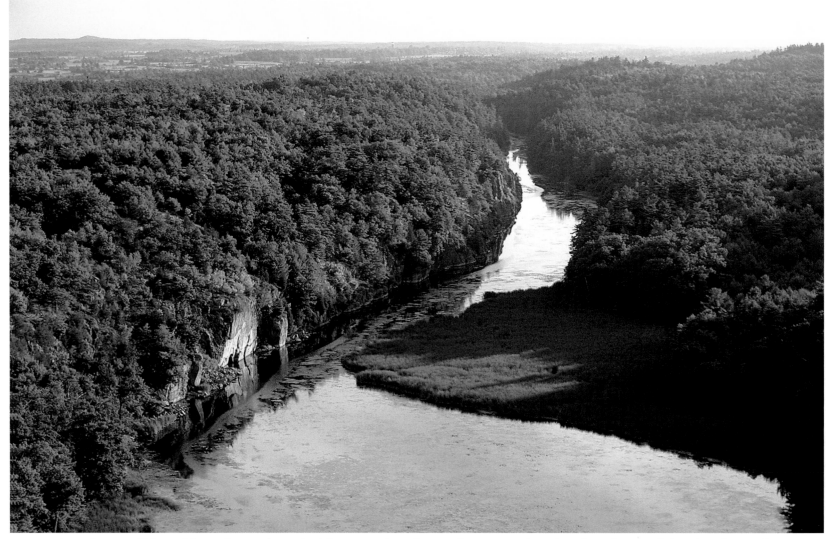

In calm conditions, I have flown through this canyon's twists and turns out into Landons Bay and the river beyond. The experience is like a front row seat in an IMAX movie in which I am the director.

Ten thousand years ago, the 1000 Islands were buried under a sheet of ice that reached over a mile higher than the height from which I took this shot. Here at Wellesley Island's Eel Bay, the glaciers left behind a sandy bottom reminiscent of the Caribbean.

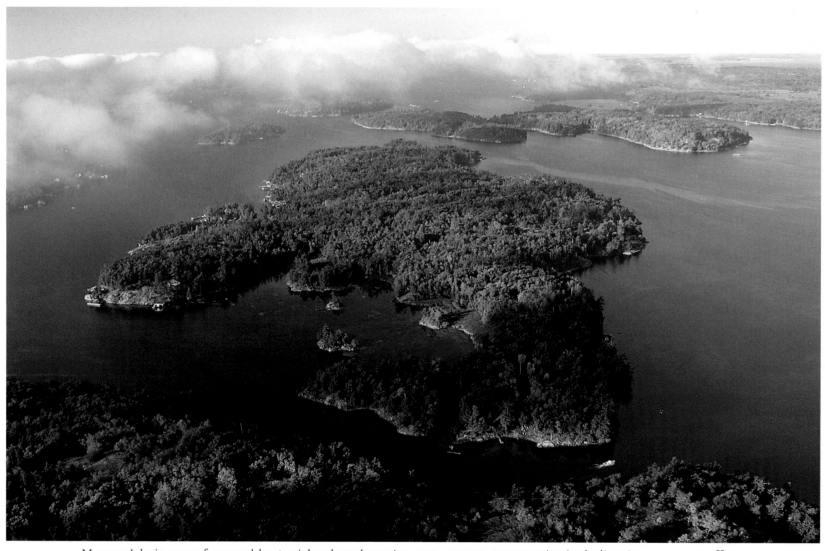

Murray Isle is one of several larger islands to have its own cottage community including its own post office.
At one point when the grand Murray Hill Hotel was still operational, the island was a major stop on the steamboat route.

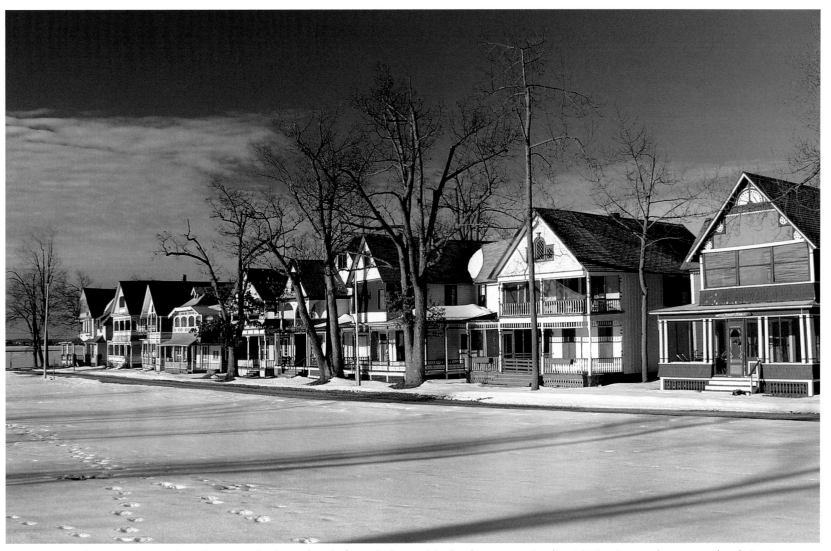

To visit Thousand Island Park on Wellesley Island, founded as a Methodist resort in the 1870s, is to take a step back in time to a gingerbread fairyland with a close-knit community of families, many of whom have summered here for generations.

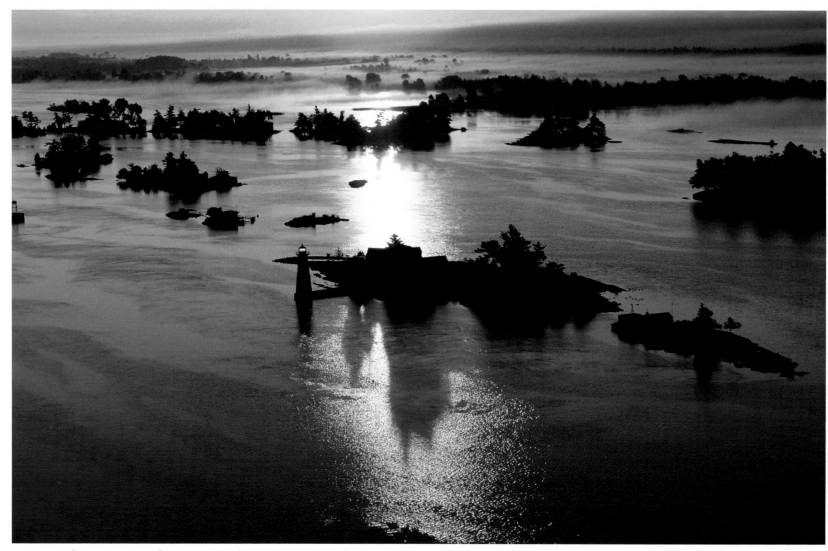

After a career of pirating in the 1000 Islands, followed by a period in prison, Bill Johnston was eventually pardoned. In 1852, he turned to a more sedate career as the first keeper of Rock Island Light.

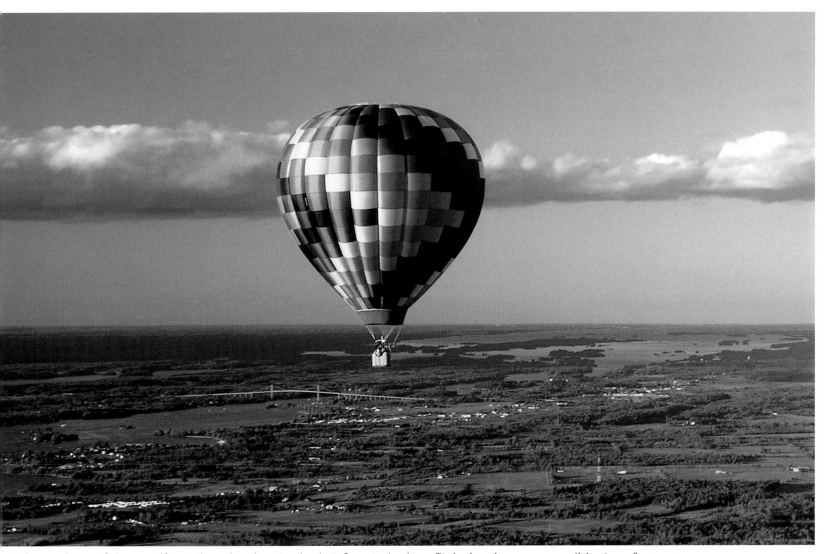

I have always felt myself privileged to live in the brief period when flight has become possible. I prefer to steer my own course in my own plane, but on a gentle summer evening, I can imagine no better flying machine than a balloon.

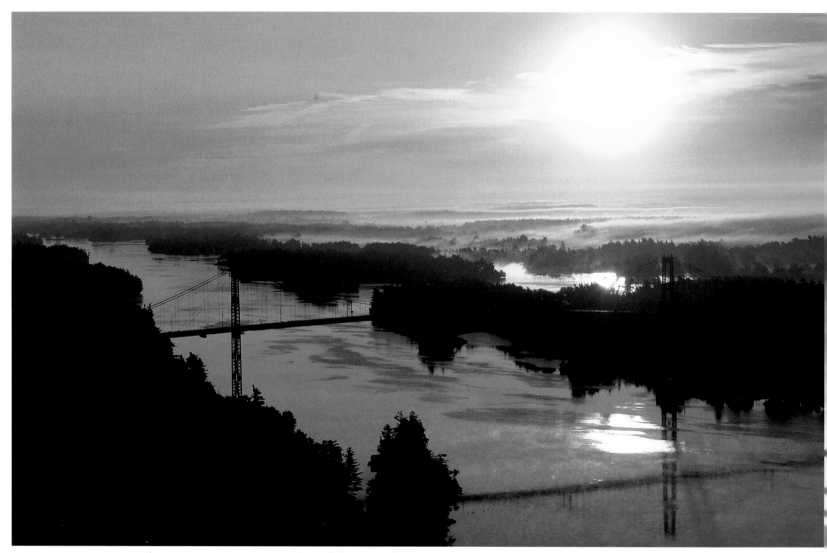

Dawn paints its own pictures, this of the American Span which carries traffic from the U.S. mainland 150 feet above the St. Lawrence Seaway to Wellesley Island.

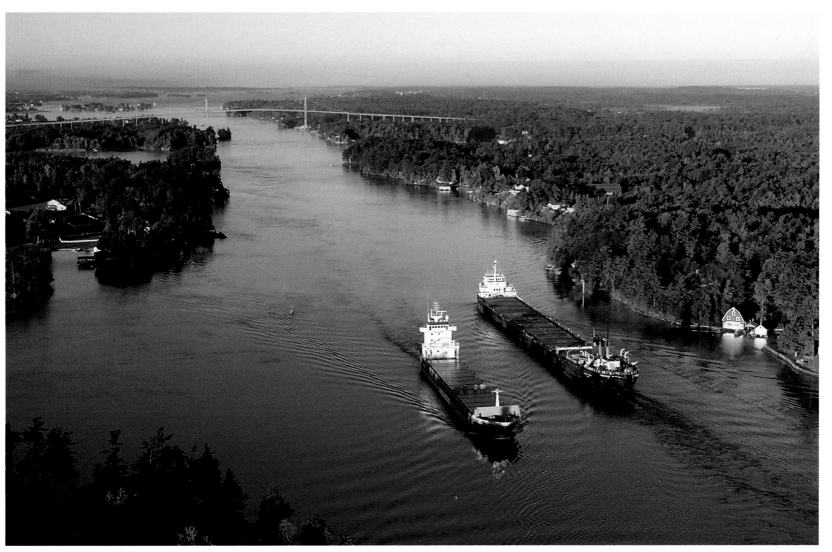

The thousand-mile passage from the Great Lakes to the Atlantic Ocean is at its narrowest through the 1000 Islands.
River pilots with local knowledge board all ships to guide them safely through the confined and shoal-infested waters.

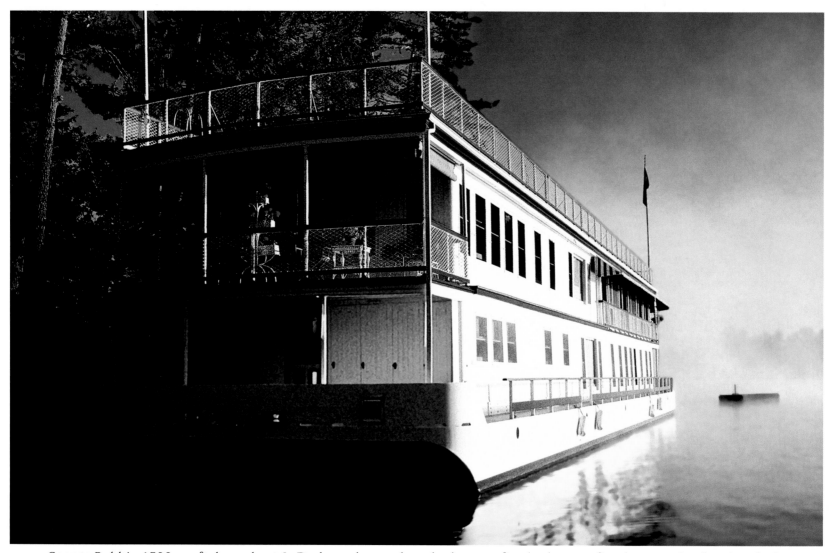

George Boldt's 6500 sq. ft. houseboat LaDuchesse boasted ten bedrooms, five baths, two fireplaces and a dancing deck. His guests were among the first to enjoy a new (1000 Islands) salad dressing, which later gained world-wide popularity.

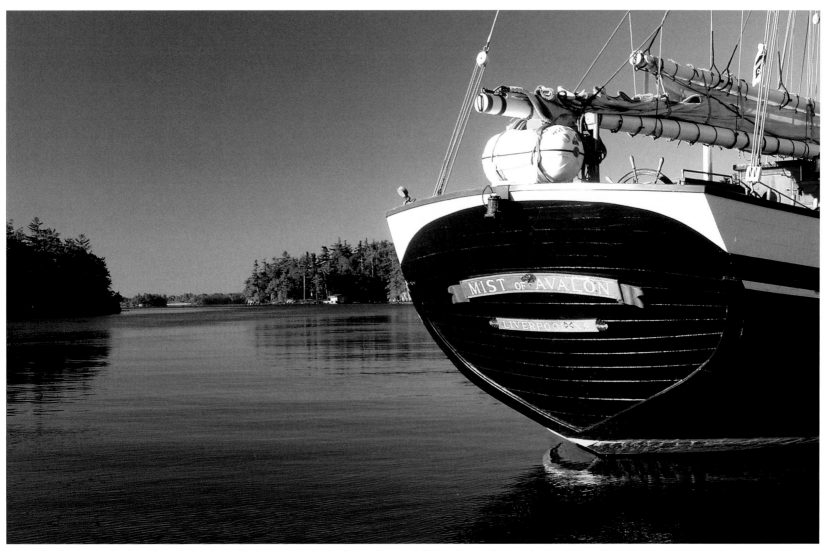

Built to work the Grand Banks off Nova Scotia before the cod fisheries collapsed, the Mist of Avalon was lovingly restored by an Ivy Lea marina owner where she now resides, adding considerable charm to an already lovely area.

Spring in the International Rift, a passage that narrows to just a few yards between Wellesley and Hill Islands in the background of this scene. Boats navigating the narrows have one side in Canada, while the other is in the U. S.

Having taken off before dawn to be in position at sunrise, I found a low cloud cover developing in the area I wanted to shoot. Turning for home, I was surprised by the suitably named Sky Deck poking through to greet me.

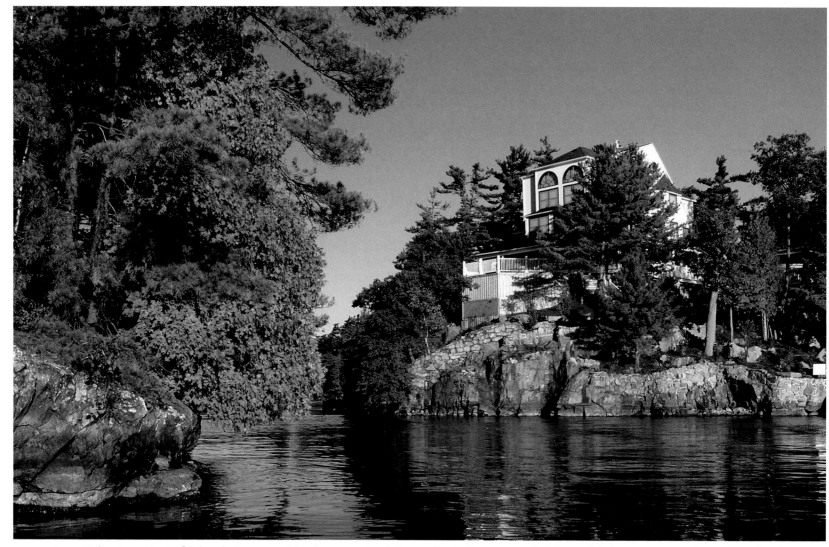

In a tight grouping of islands just outside the mouth of Smuggler's Cove near Ivy Lea, this home on Madawaska Island replaced one built in 1896 by William Devine, a founder of Columbia Records.

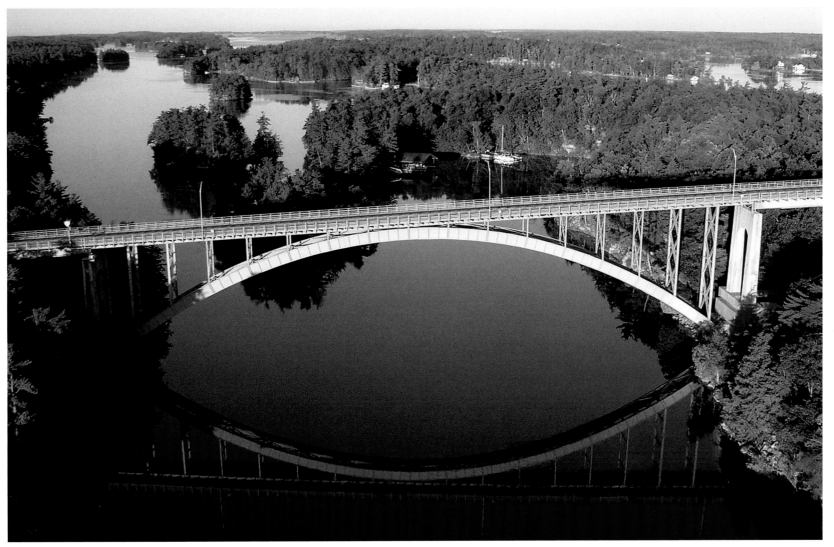

Often referred to as The Rainbow Arch, this section of the Canadian span, built in 1938, touches down on Georgina and Constance Islands, both part of the St. Lawrence Islands National Park. The Lost Channel lies beyond.

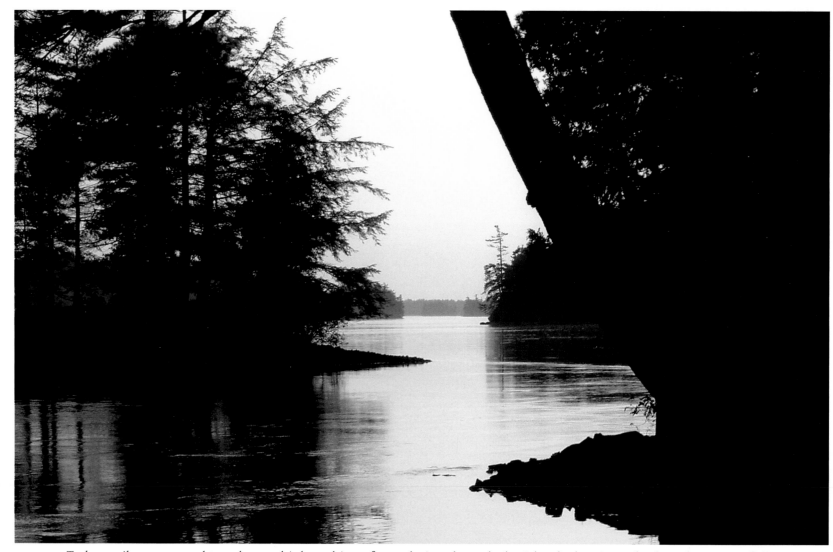

Today, sail, power, and tour boats think nothing of wandering through the islands, but in early days, boats carefully followed well-marked routes near the shore for fear of becoming lost forever in a labyrinth of islands and water.

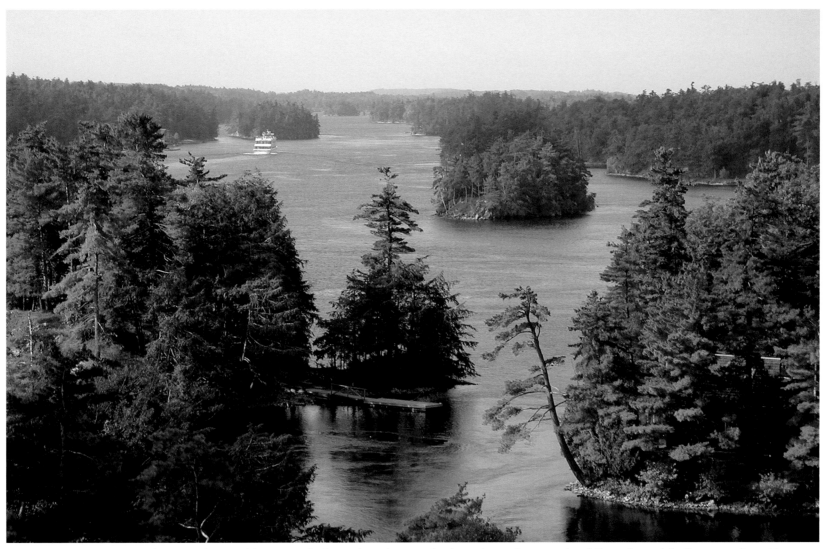

On August 14, 1760, the British warship H. M. S. Onondaga lowered a boat here, in pursuit of French and Indian attackers. Later, when the ship's crew could find neither the boat nor where they had lowered it, this area became known as "The Lost Channel."

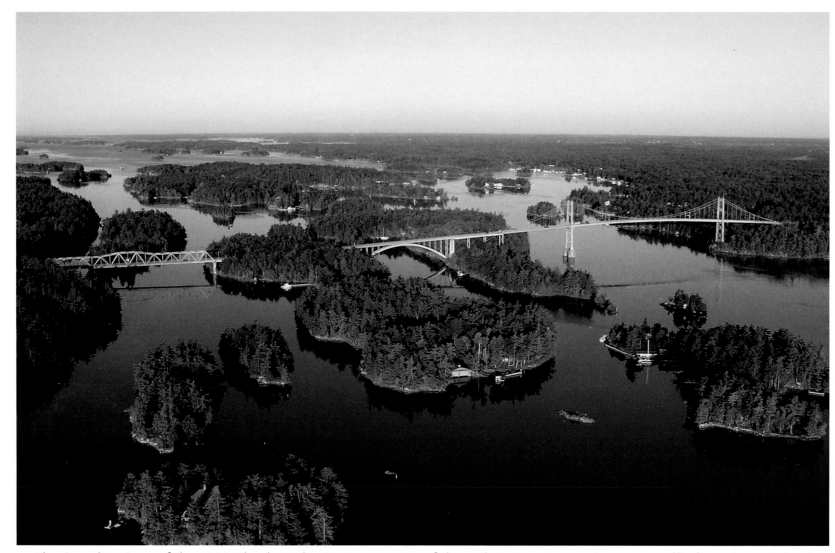

The Canadian Span of the 1000 Islands Bridge System consists of three elegant segments that carry traffic from the mainland to Hill Island, where a mile up the road a short and easily missed masonry bridge crosses the International Rift to the U.S.

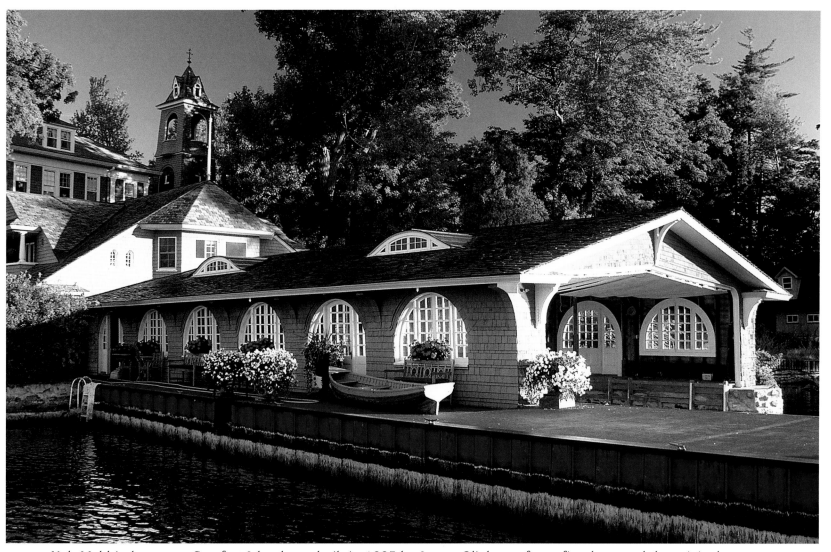

Neh Mahbin house on Comfort Island was built in 1893 by James Oliphant after a fire destroyed the original cottage. A stockbroker by trade, Oliphant was murdered in 1907 by a despondent client who had suffered major losses.

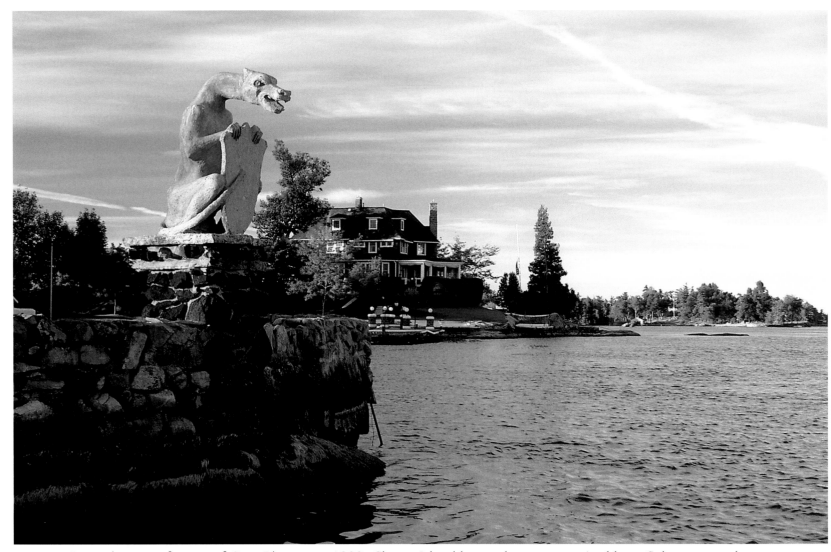

Gargoyles are a feature of Casa Blanca, an 1890s Cherry Island home that was acquired by a Cuban sugar planter, following the Spanish-American War and the consolidation of giant industries such as the sugar trust.

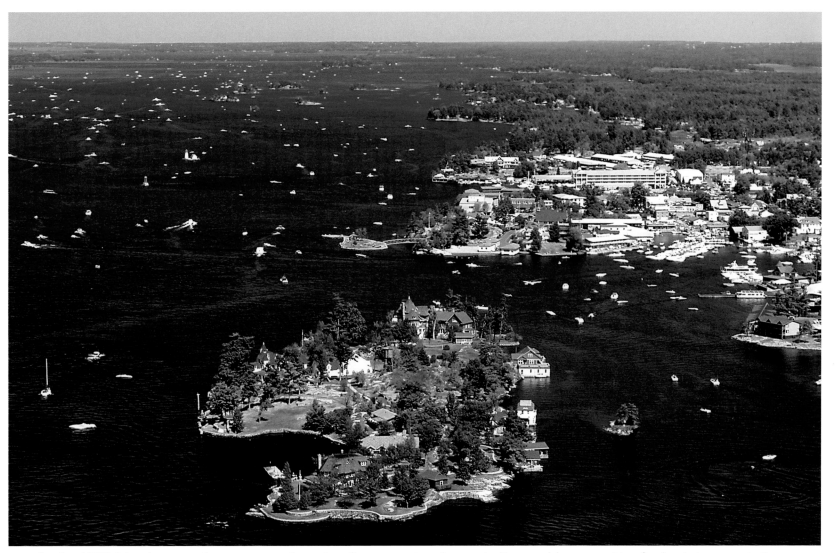

In the 1000 Islands, powerboats are used not just for recreation, but as indispensable necessities for basic transportation. Alexandria Bay, N.Y., may well be the freshwater powerboat capital of the world.

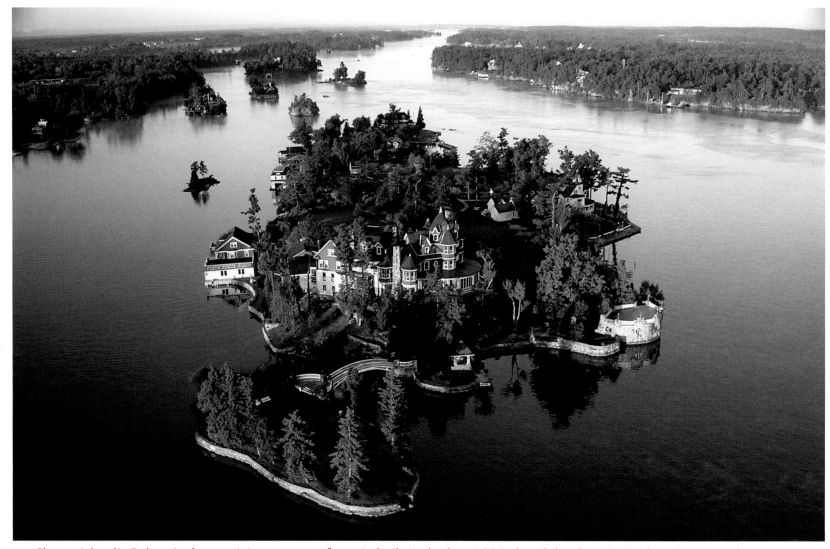

Cherry Island's Belora is the surviving cottage of a pair, built in the late 1800s by philanthropist Nathan Straus and a partner. Straus' fortune largely came from Macy's, then the world's largest department store.

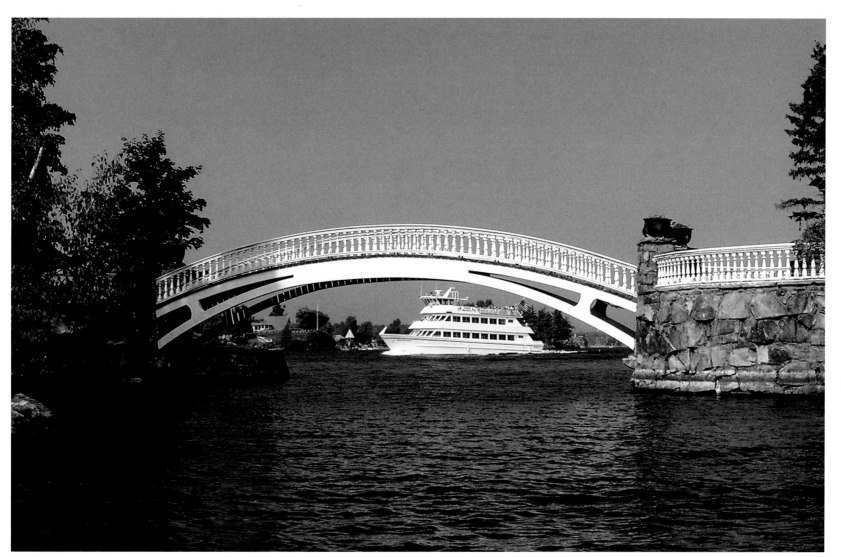

For over a century, the footbridge from Belora on Cherry Island has framed ships
of all shapes and sizes passing in the adjacent St. Lawrence Seaway shipping channel.

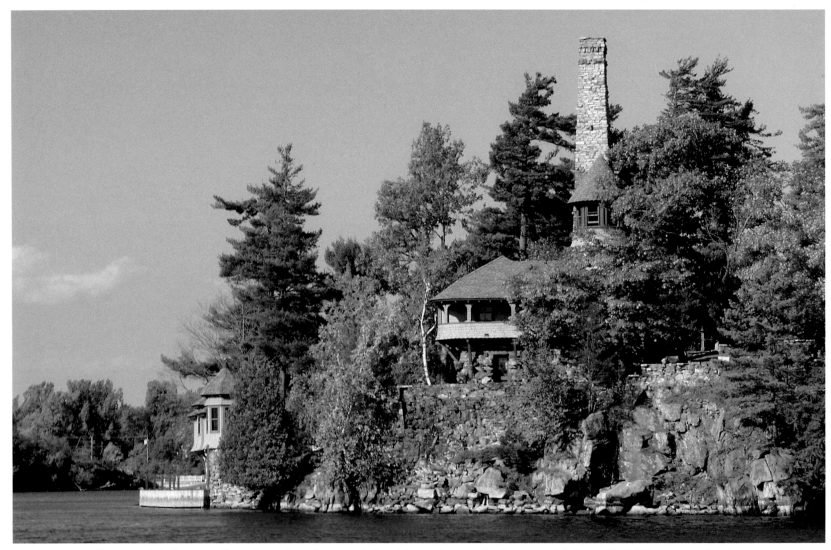

George Pullman (of Pullman railroad car fame) invited President Ulysses S. Grant and fellow Civil War Generals Sherman and Sheridan to his island in 1872. The press wrote glowing reports of the area, initiating a popularity that continues to this day.

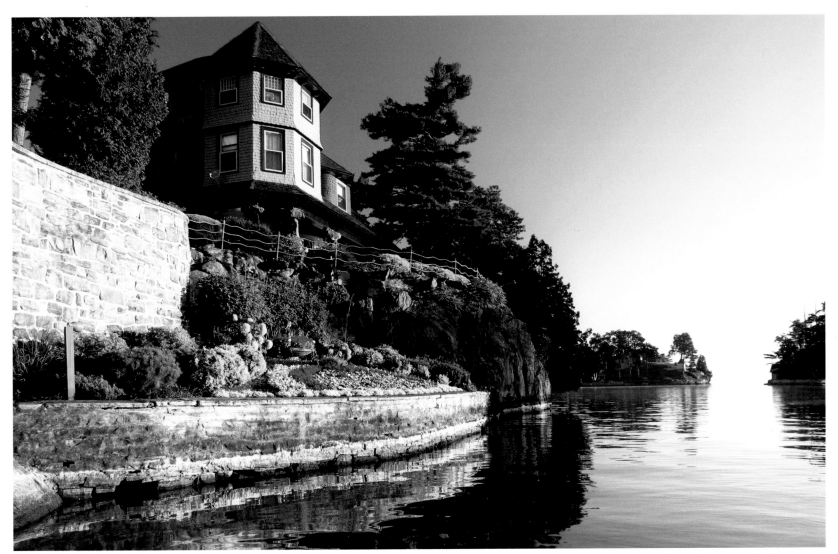

Prior to building this cottage on Nobby Island in 1884, contractor Seth Pope found six mysterious, very large human skeletons. They were placed in a simple box and re-buried without any investigation allowed. The episode remains a mystery.

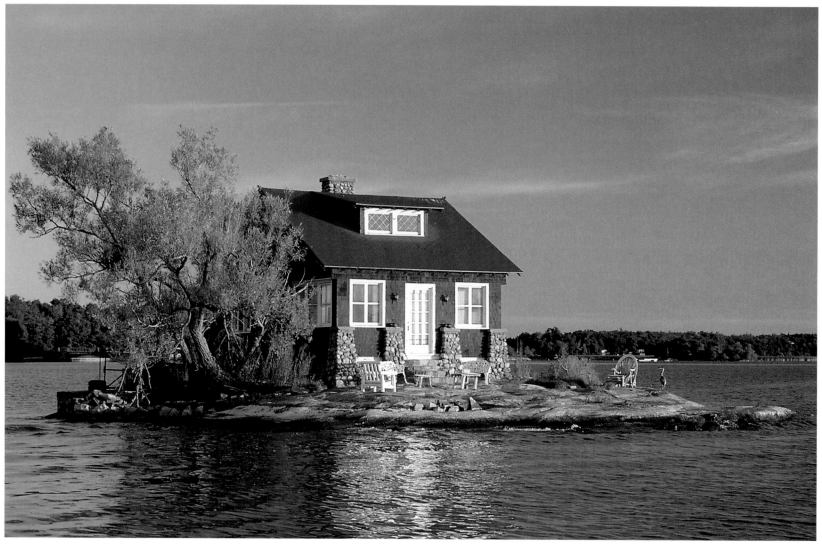

Perhaps the ultimate contrast in island homes is this cottage that sits next door to Heart Island's fabulous Boldt Castle. Tour guides joke that this was for Boldt's mother-in-law.

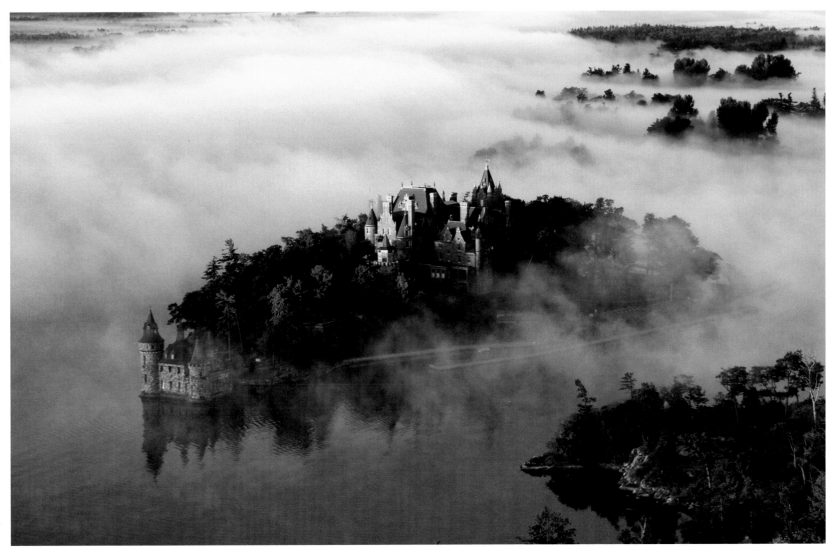

An unfinished dream, George Boldt's magnificent castle and Heart Island complex was a gift for his beloved wife. Devastated by Louise's death in 1904, he halted construction prior to completion and never returned to the island.

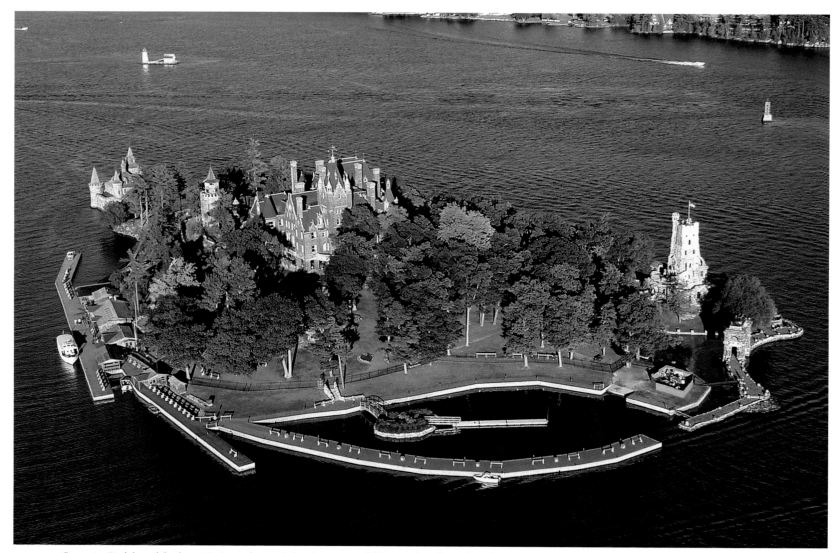

George Boldt added an "e" to the original name of Hart Island and reshaped the island into a heart, building a castle as a testament of his love for wife Louise. The Arch of Honor on the right marks the apex of the heart.

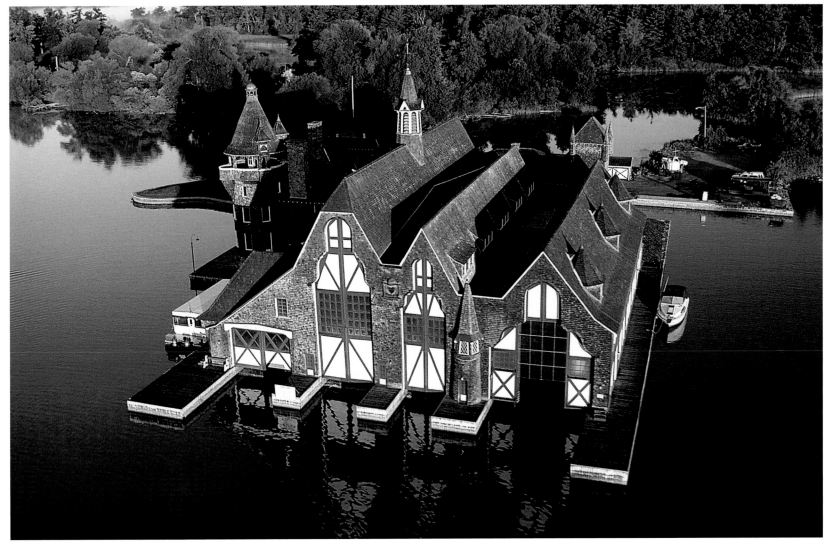

George Boldt's Yacht House housed some sixty craft, from the 104-foot houseboat LaDuchesse and 102-foot steam/sail yacht Louise to racers, motor yachts, and workboats. A 60-foot door gave Louise access with masts and rigging standing.

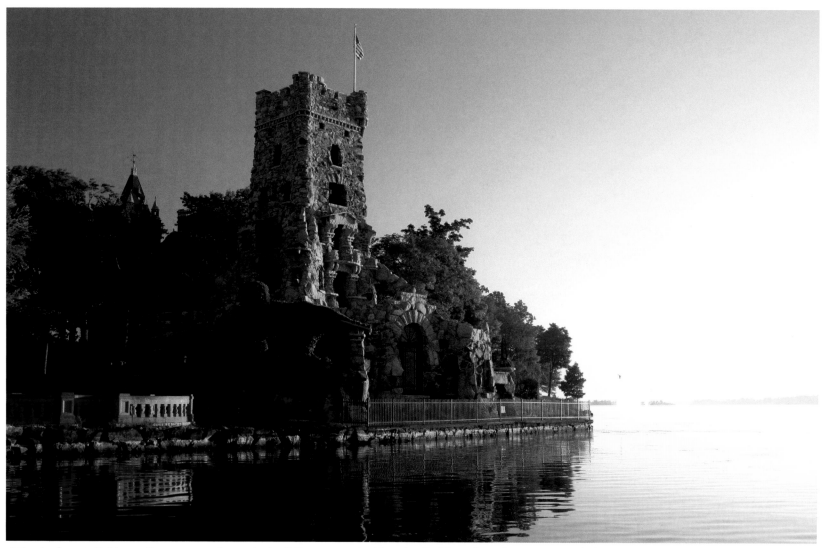

Ninety-foot tall Alster Tower was the only building occupied by the Boldts after they removed their earlier cottage on Heart Island. The tower housed guest suites, a kitchen, billiard room, library, performing stage, plus two bowling alleys in the basement.

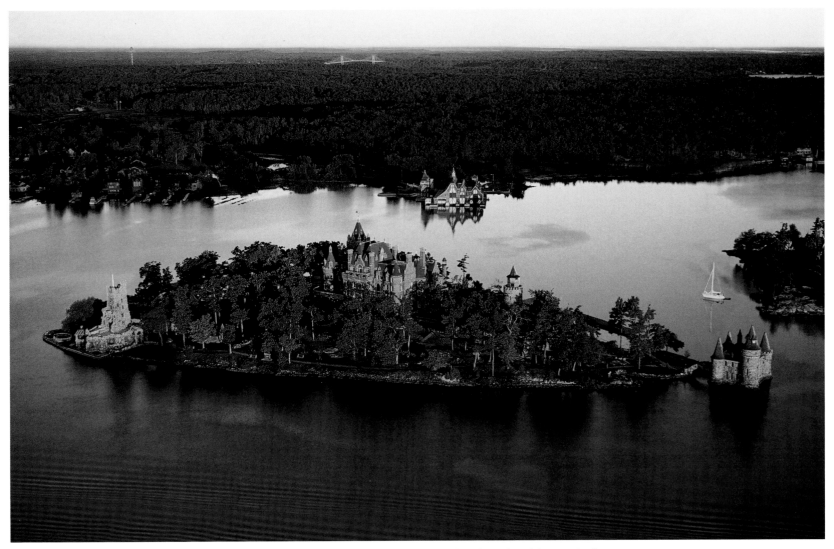

Early in the 20th century, an effort was made to purchase Heart Island and Boldt Castle for use as a permanent summer White House for Woodrow Wilson and future Presidents. Funding failed to materialize when World War I intervened.

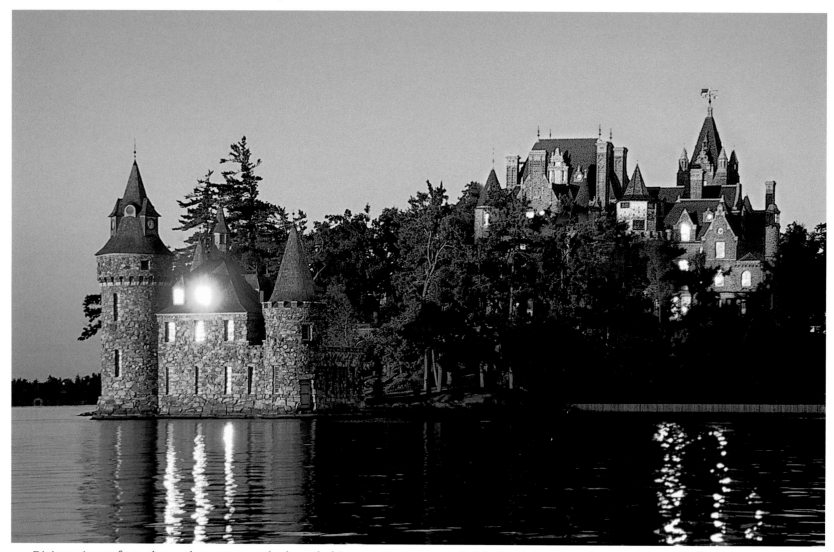

Rising ninety feet above the water, a clock and chimes tower crowns Boldt Castle's power house. Fifteen bells ranging in size from twelve to fourteen feet used to ring out on the quarter hour. They could also be played from a keyboard in the castle.

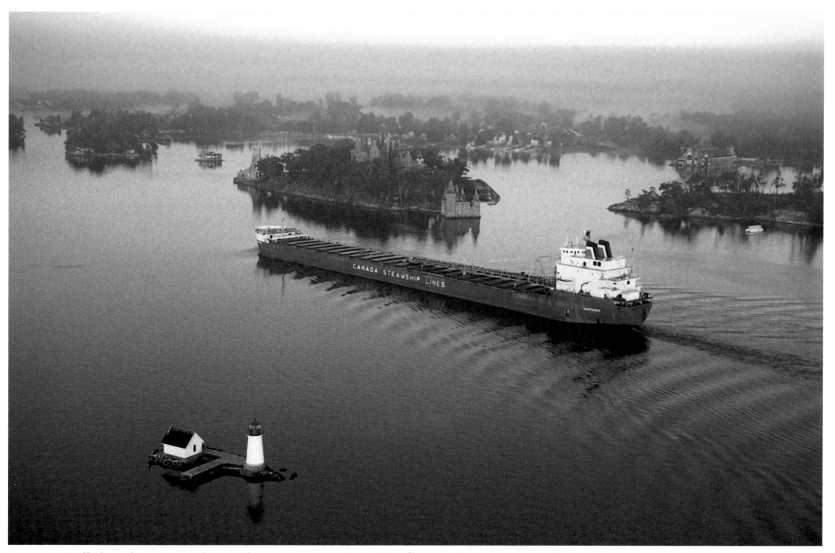

Not all ships have passed in such serenity. On the night of November 20, 1974, the Roy A. Jodrey, similar to this ship, struck a shoal here by Boldt Castle. It struggled upstream another mile and a half before sinking in 240 feet of water.

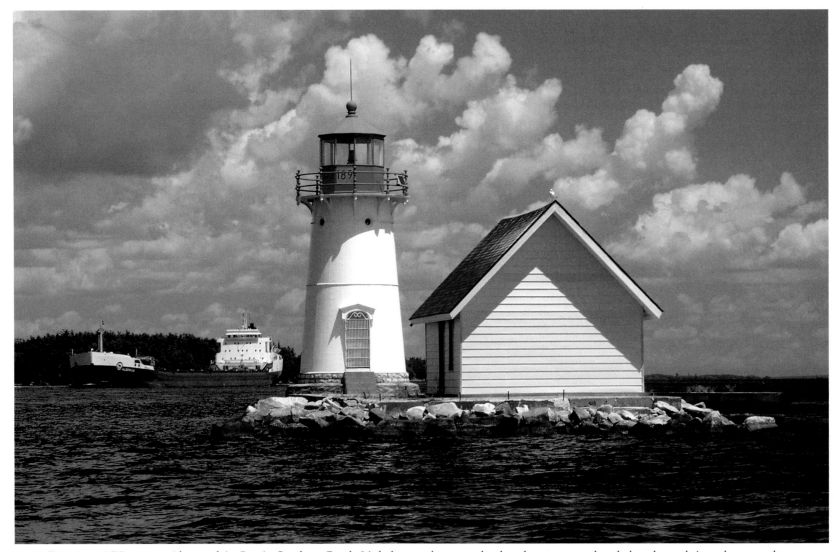

For over 150 years, Alexandria Bay's Sunken Rock Lighthouse has marked a dangerous shoal that has claimed more than its fair share of ships. The shoal lies just across the channel and a few hundred feet downstream from Boldt Castle.

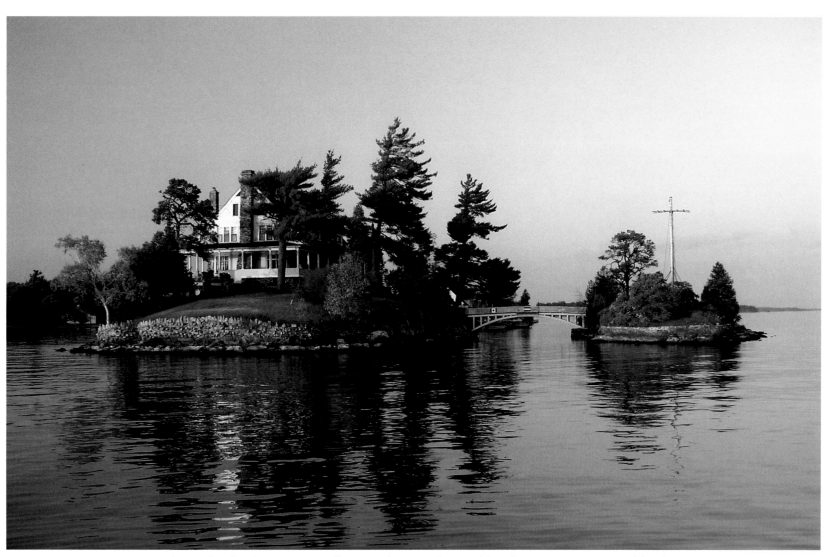

Zavikon Island is known to millions as having the world's shortest international bridge,
joining the home in Canada to its backyard in the United States.

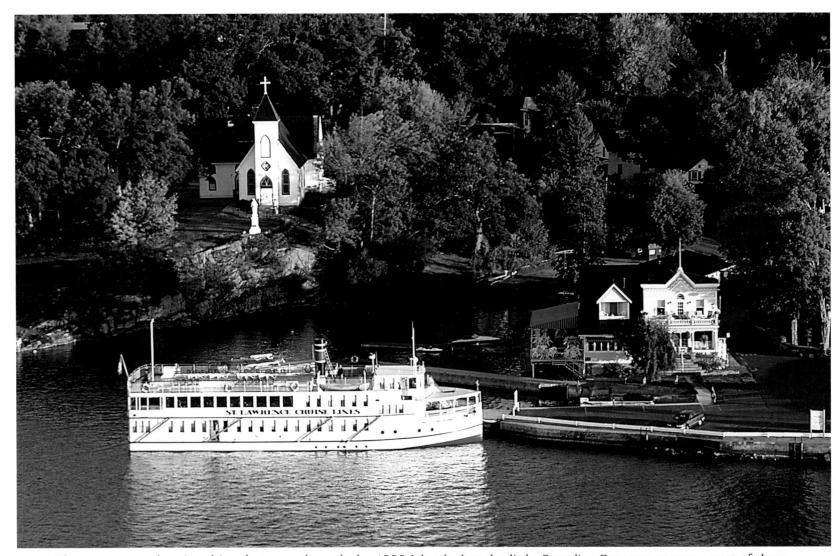

There are several cruise ships that pass through the 1000 Islands, but the little Canadian Empress seems a part of them. I have come across her anchored, docked, or cruising many times and in many places. Here she wakes up in Rockport.

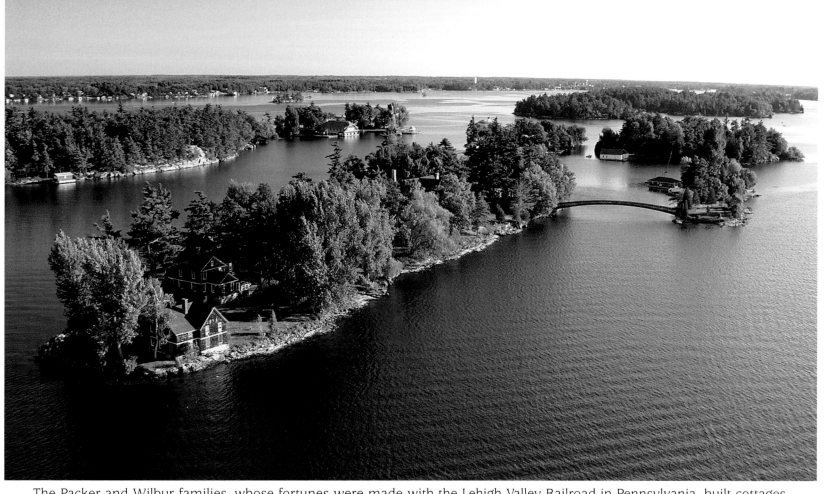

The Packer and Wilbur families, whose fortunes were made with the Lehigh Valley Railroad in Pennsylvania, built cottages on Sport and Little Lehigh Islands. They traveled here in their private railroad car and side-wheel steam yacht.

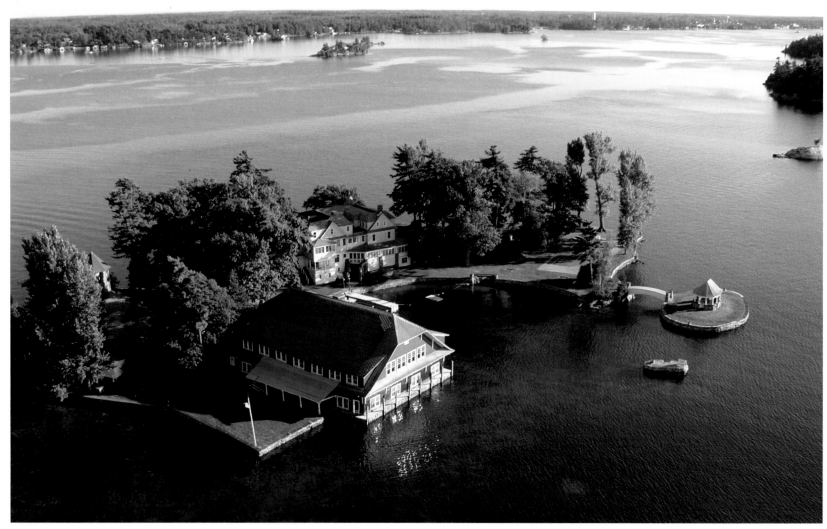

Samuel Briggs purchased Ina Island in 1871 for $150. Subsequent owner Arthur Hagan married his laundress Emma, who entertained the gentry in their boathouse ballroom. Later still, Ina Island became a brothel.

Boathouses in the 1000 Islands come in all shapes and sizes. Like this one on Baby Tar Island, they often serve many more functions than simply a protected place to keep a boat.

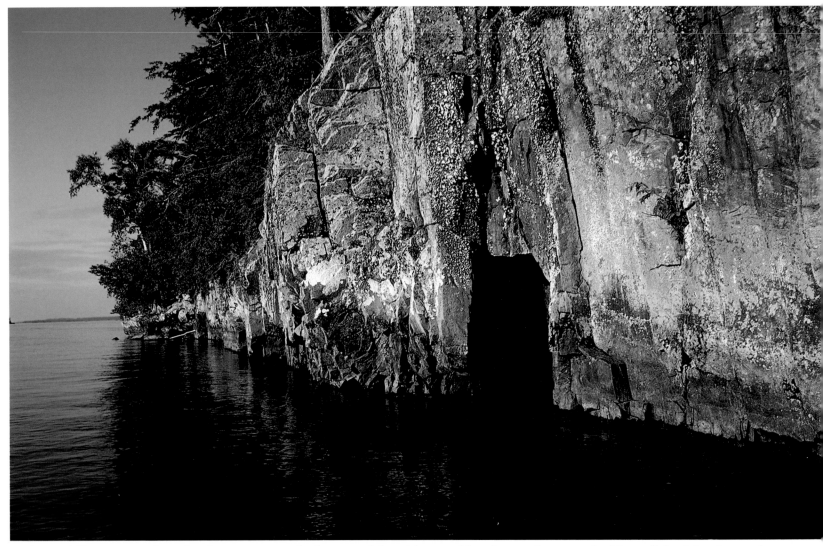

These cliffs on Ironsides Island are composed of some of the oldest and hardest rock on earth. Most of the islands are the roots of ancient mountains that have stubbornly resisted erosion while the river washed away everything around them.

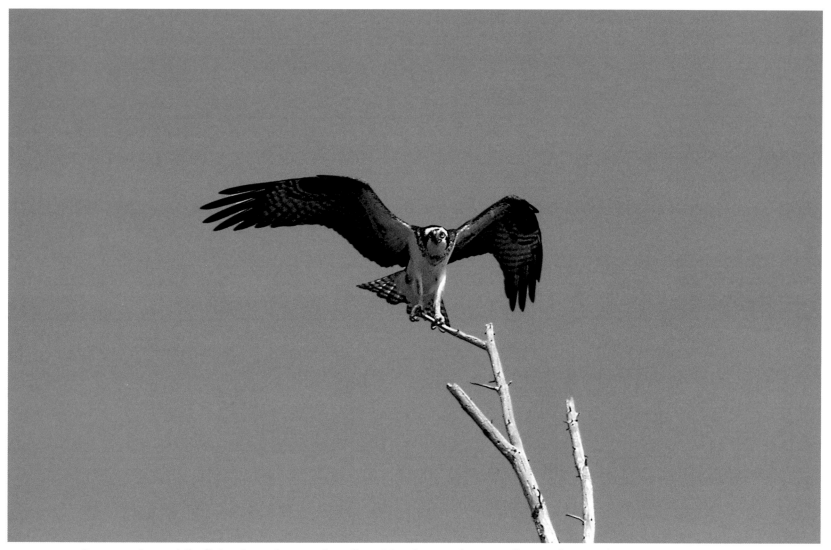

One evening, while flying low along a shoreline, I inadvertently came face to face with an osprey in its nest. Far from being intimidated by the plane, it charged me!

An improbable sight elsewhere, but not uncommon here, where islanders can be very creative in answering their needs.

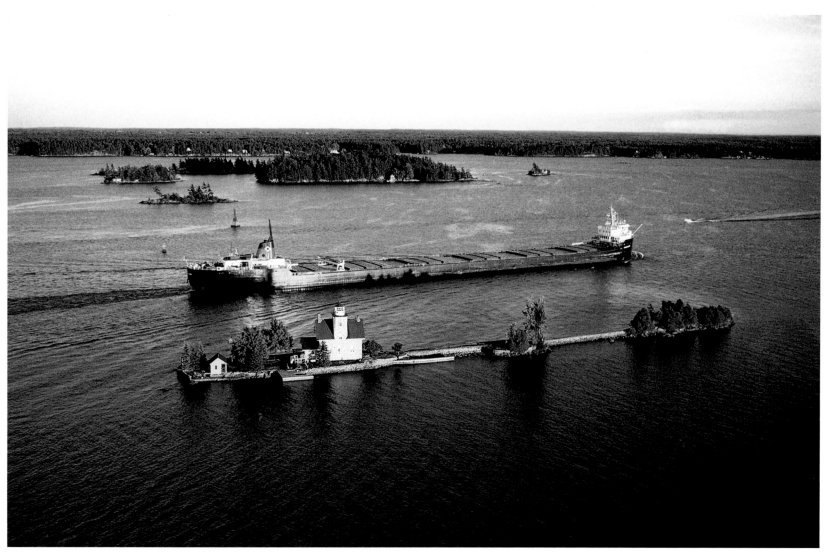

Low on fuel at the end of a photo run, I saw this "photo op" developing while the ship was still miles away.
I landed and waited before popping up to get this shot just as the sun set.

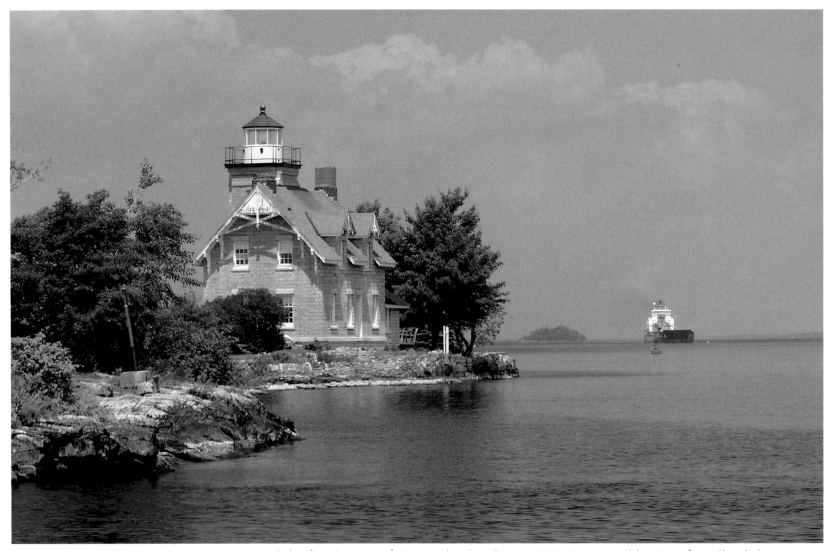

Capt. William Dodge was appointed the first keeper of Sister Island Light in 1870. He trained his Newfoundland dog to swim the quarter mile to bring messages to his friend William "Billy" Buell on Grenadier Island.

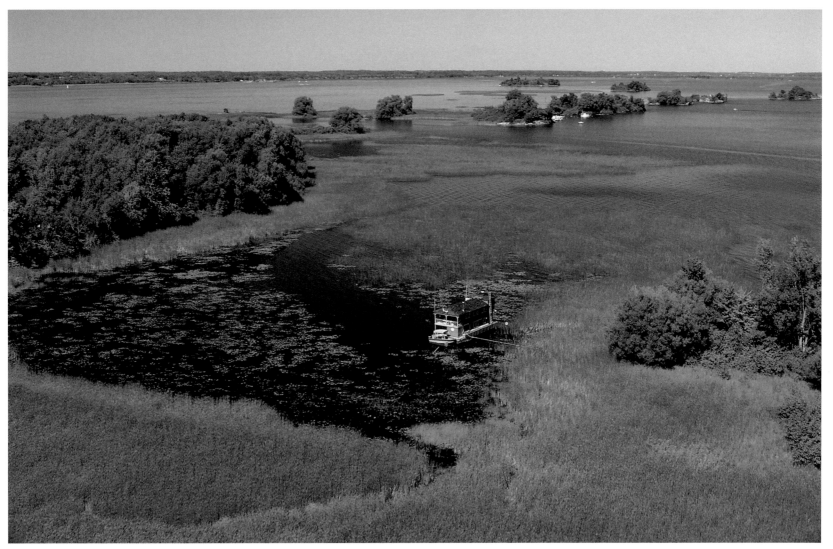

In the late 1800s, a creative island home-builder built this two-story floating home, complete with balcony and dock so he could enjoy the comforts of home at island worksites rather than face a lengthy commute.

Most common in autumn, sea smoke is formed when the warmth of the water rises into much cooler air, creating an infinite variety of magical scenes on the river.

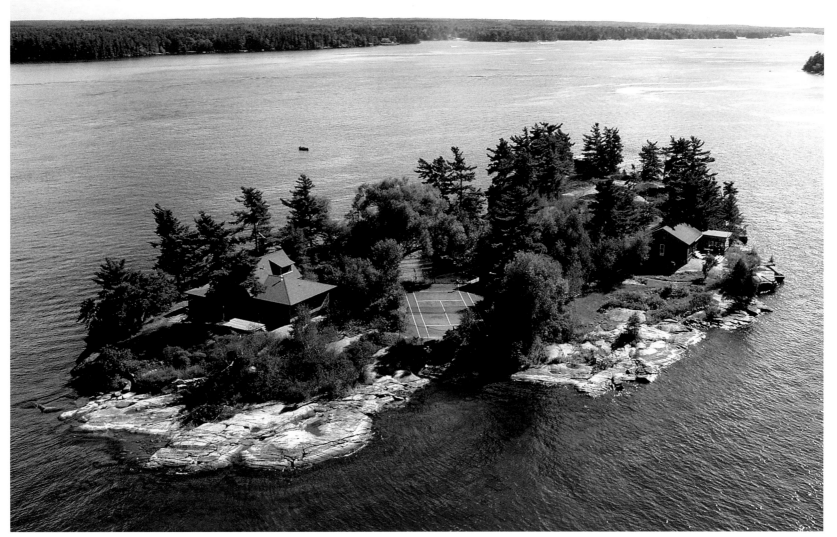

The four cottage owners on Halfway Island near Chippewa Bay share a tennis court as well as an island.

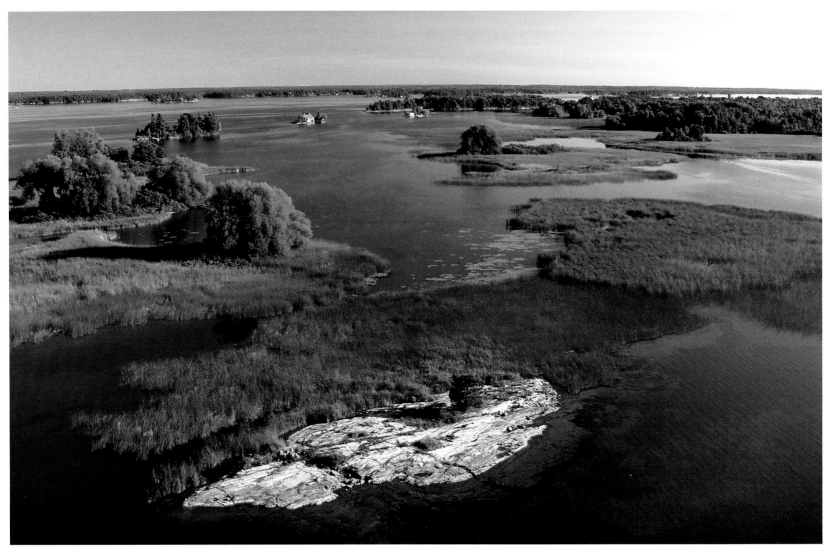

Here on Adelaide Island and on nearby Squaw Island, archeologists have unearthed artifacts from native encampments that date from the time of European contact in the 1600s back to 5000 BC.

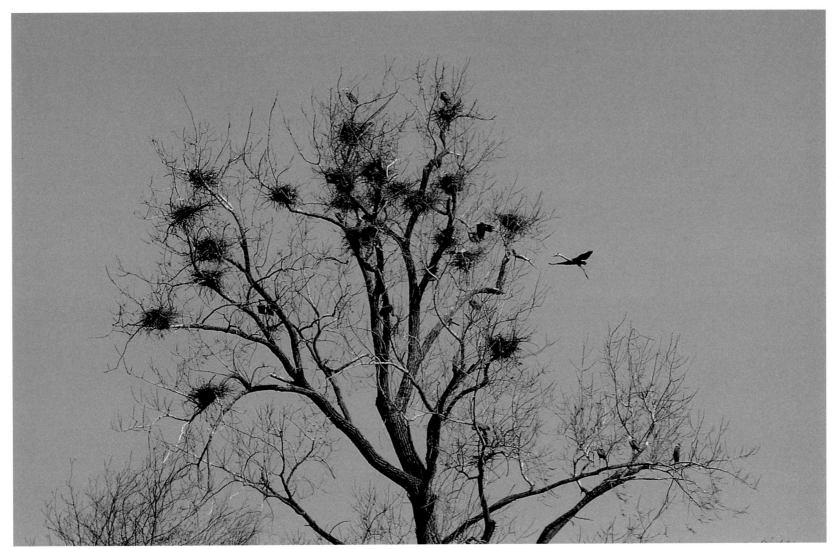

Reminiscent of pterodactyls, great blue herons give a Jurassic Park feel to a few islands that serve as home to their busy rookeries.

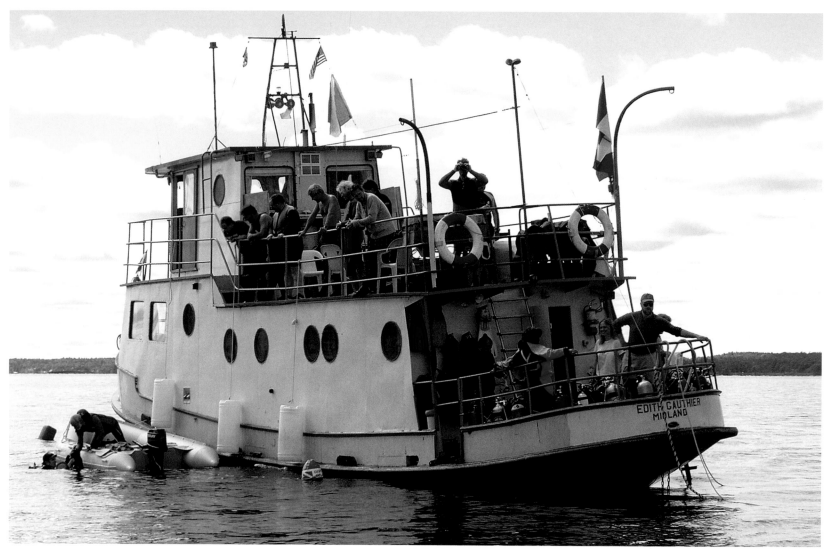

Thanks to clear water and many shipwrecks, the 1000 Islands are said to offer the finest freshwater diving in the world. Here, divers surface from the America, which lies at the bottom of the channel in front of Dark Island's Singer Castle.

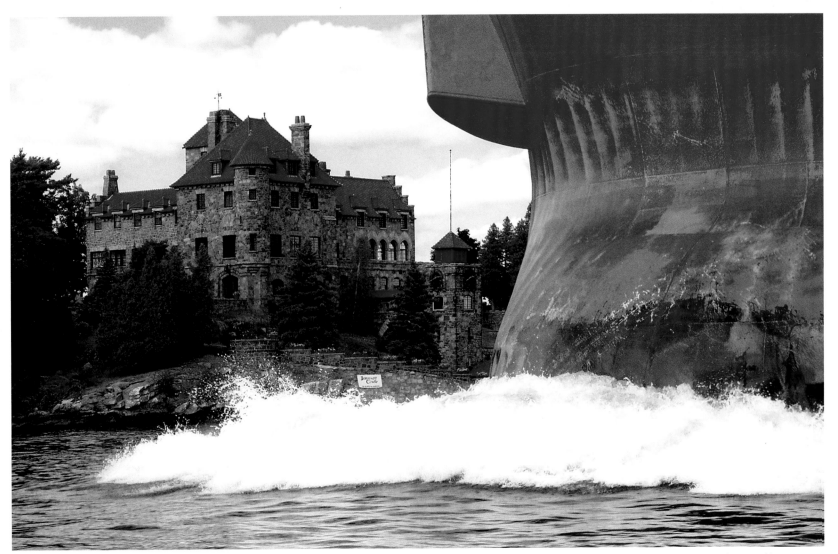

Ships from around the world pass within a stone's throw of Singer Castle. When their sewing machines were slow sellers at $42 each, Singer's Frederick Bourne conceived a purchase program of one dollar per week that made him a fortune.

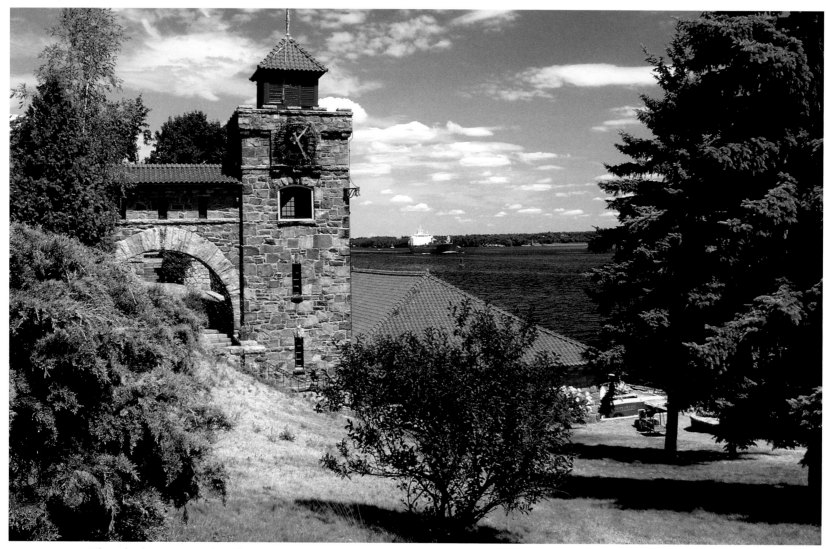

The clock tower and archway on Dark Island provide protected passage from the boathouse to the castle. Hidden stairways and passageways in the castle's walls allowed the servants to unobtrusively serve guests.

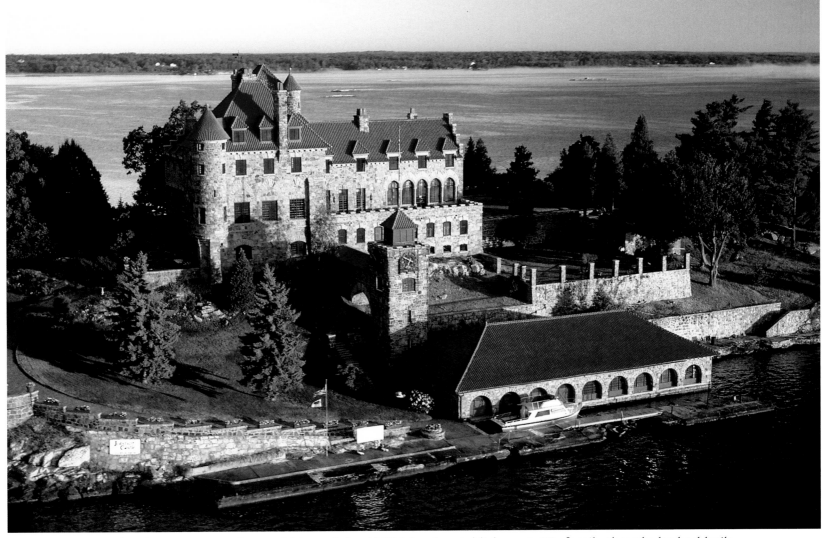

Frederick Bourne was the wealthiest of the 1000 Islands establishment. His family thought he had built a small hunting lodge on the river until they rounded Chippewa Bay's Cedar Island for their first visit.

Many islanders regard themselves as privileged stewards of irreplaceable properties. Future generations will take pleasure in this Chippewa Bay boathouse built in the 1890s by New York Yacht Club Commodore C. B. Orcutt.

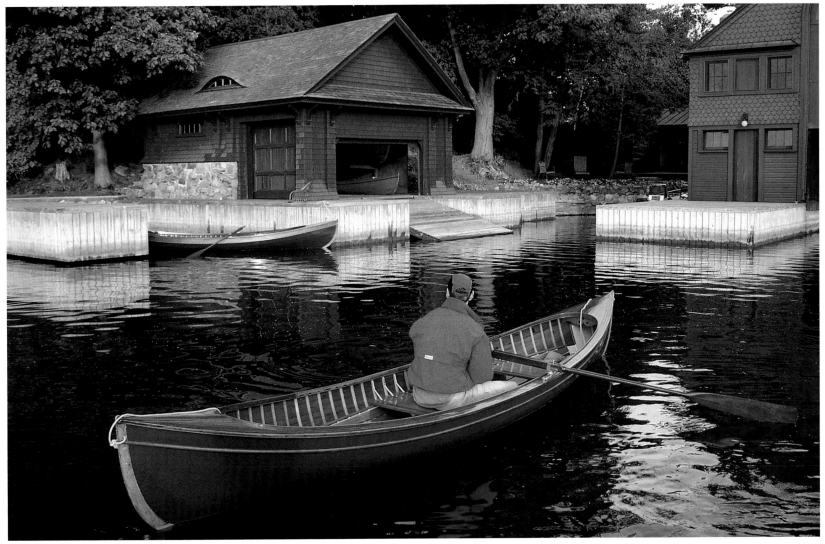

The St. Lawrence skiff is the icon of 1000 Islands boats. Its design evolved to efficiently serve fishing guides who were expected to row their clients as far as forty miles in a single day's outing as well as weather unexpected storms.

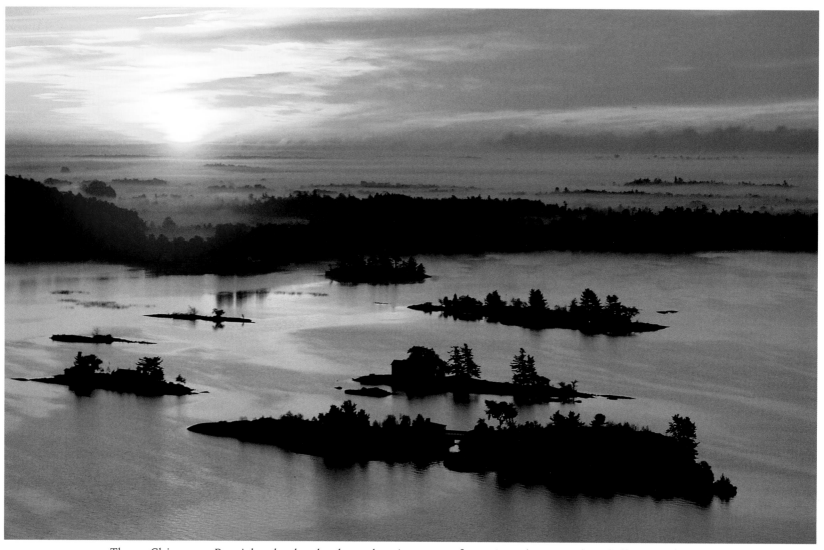

These Chippewa Bay islands clearly show the signature of passing glaciers. The Bluff Island home in the foreground straddles a gap between the two halves of the island. Boats can pass beneath.

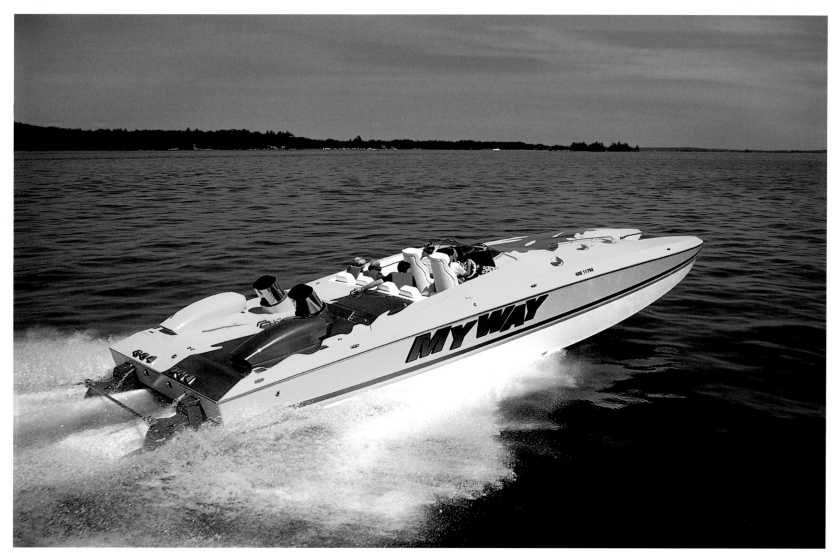

The annual 1000 Islands Poker Run is the biggest event of its type in North America, attracting exotic powerboats from near and far. Taking things to an extreme, this catamaran is more than adequately powered by two helicopter turbines.

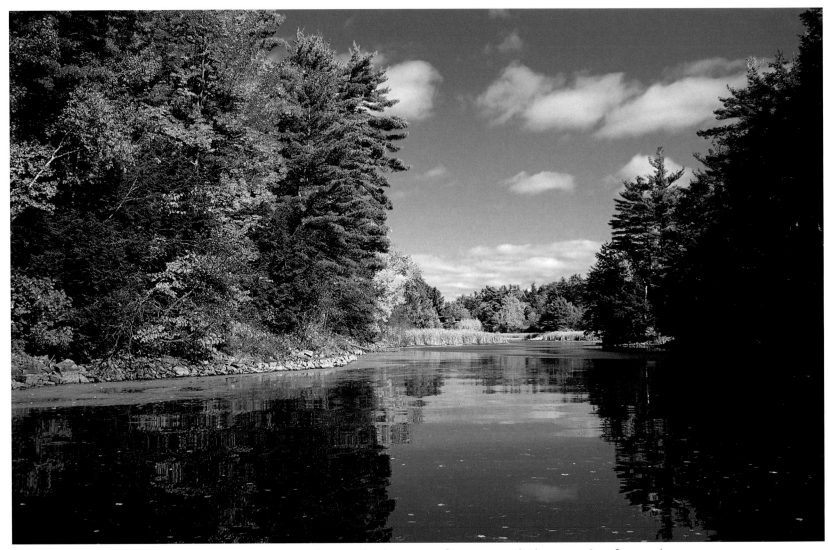

MacIlhennys Creek is one of several tributaries of Jones Creek that together form a large and ecologically important wetland that contributes to the diversity of the 1000 Islands.

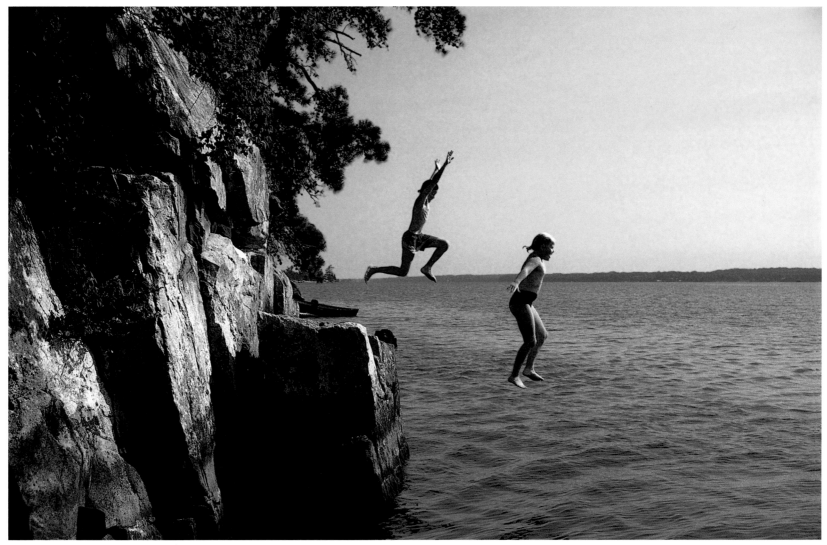

According to legend, the Indians named the 1000 Islands "Manitouana" meaning "The Garden of the Great Spirit." Today it continues to be a very special place to all who come here.

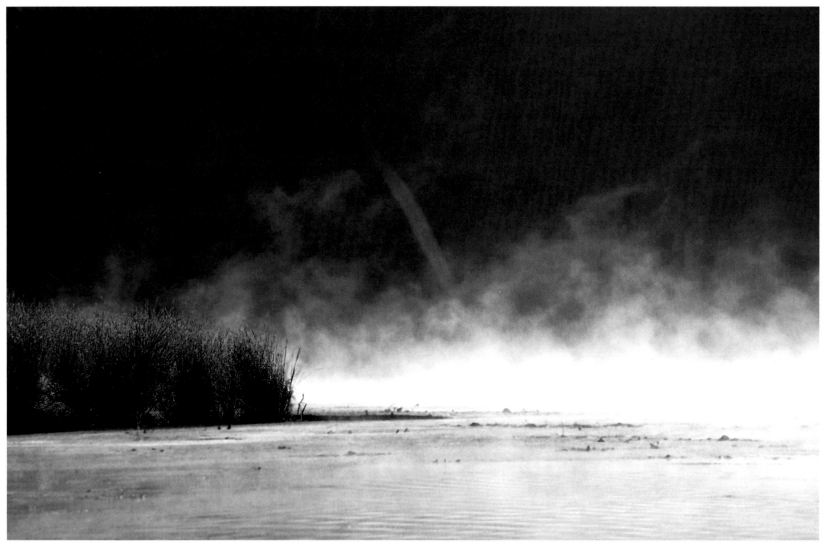

The warmth of the morning sun begins to stir dawn's mists here at Jones Creek, where Father Simon LeMoyne, the first known European to visit the area in 1654, reported the existence of an Indian village called Toniata.

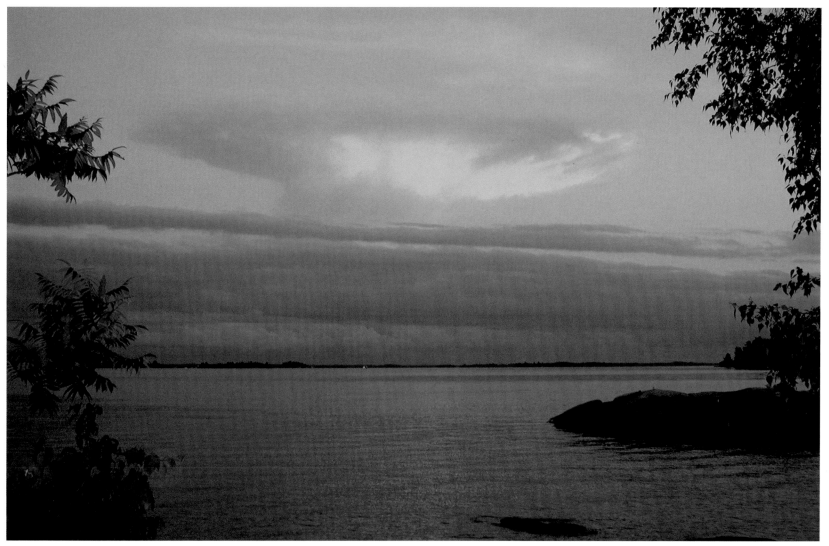

Distant storms can provide impressive entertainment as well as beautiful backdrops like this cumulonimbus, whose anvil top is lit by a sun that has already set.

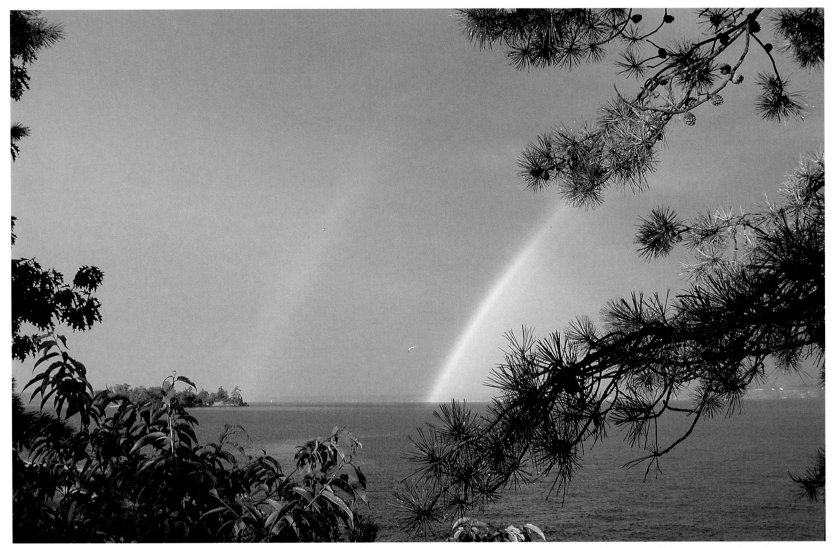

The grand vistas from these islands are a rainbow watcher's delight. The microclimate on the river allows unusual and rare species like this pitch pine to prosper. Its sap was used to make birch bark canoes as well as to treat infection in wounds.

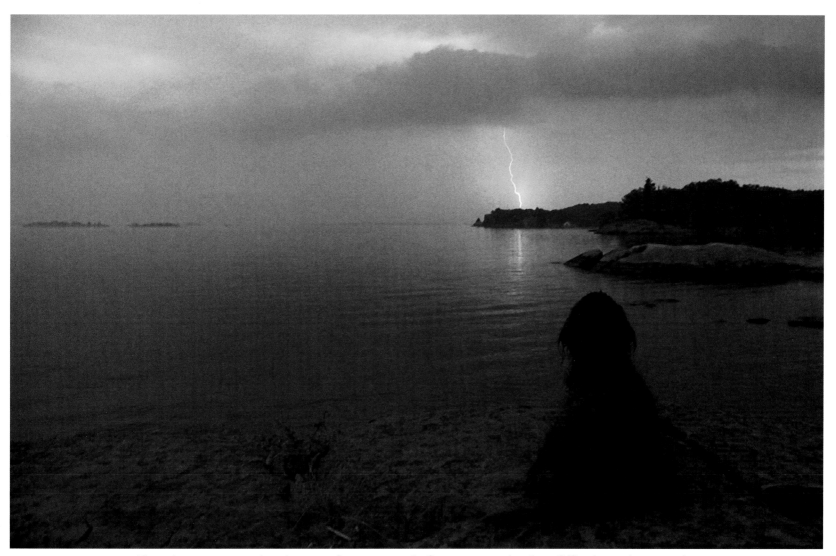

Thunderstorms on the river are frequent and often spectacular, but difficult to photograph.
I got lucky with this lightning strike while my dog watched the show.

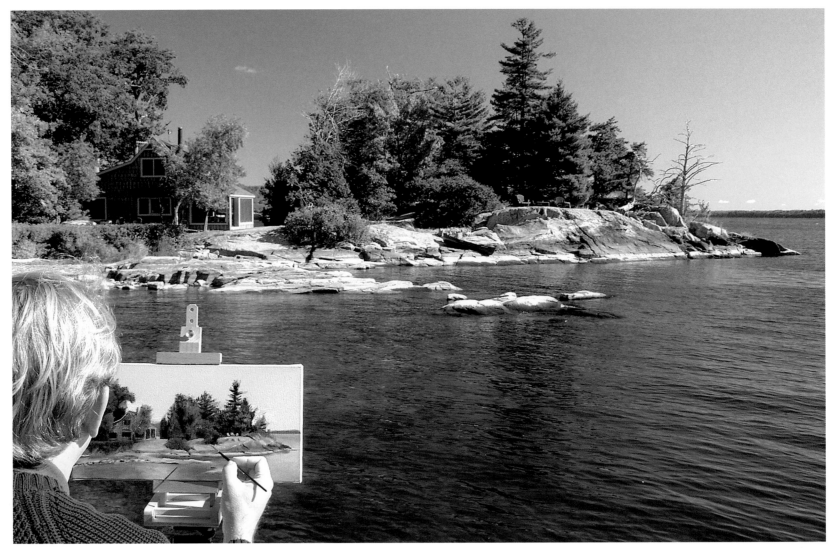

Artist Michael Flahault is one of many who have discovered that the 1000 Islands provide wonderful opportunities to exercise their talents. Frederic Remington produced many of his turn of the century masterpieces from his nearby Temagami Island studio.

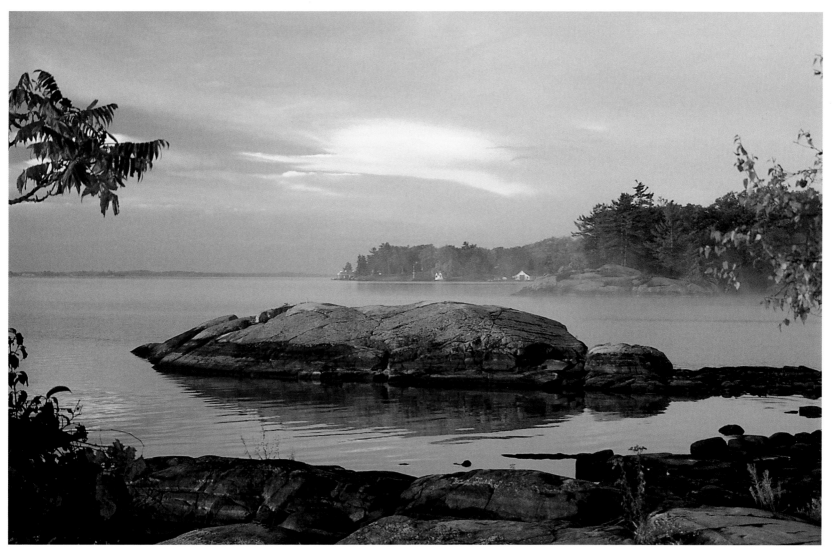

Fall colors and frost come much later to the islands in the river than inland due to the lingering warmth of the water. Many islands have been named after the crops they grew as farmers took advantage of their longer growing season.

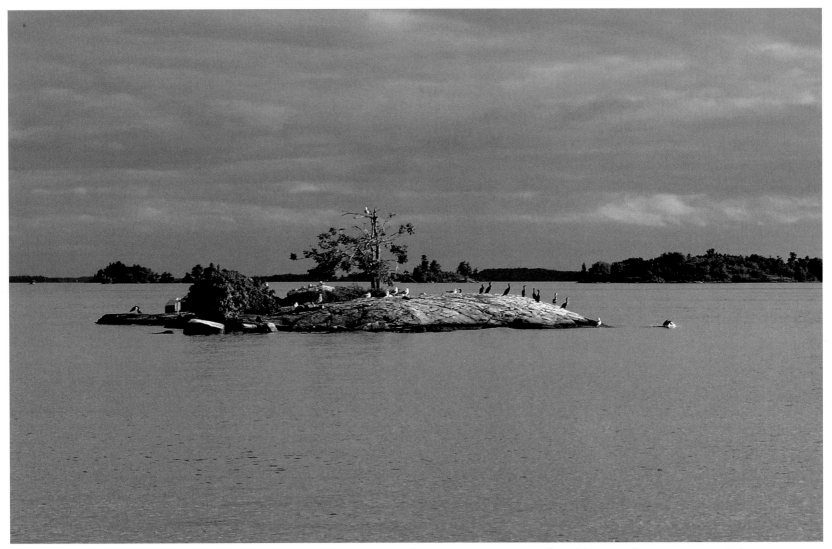

Some say that to qualify as an island, an islet must be above water year round and have at least one tree. Others insist on two. In either case, the seagulls and cormorants have claimed this one in the Amateur Islands as home.

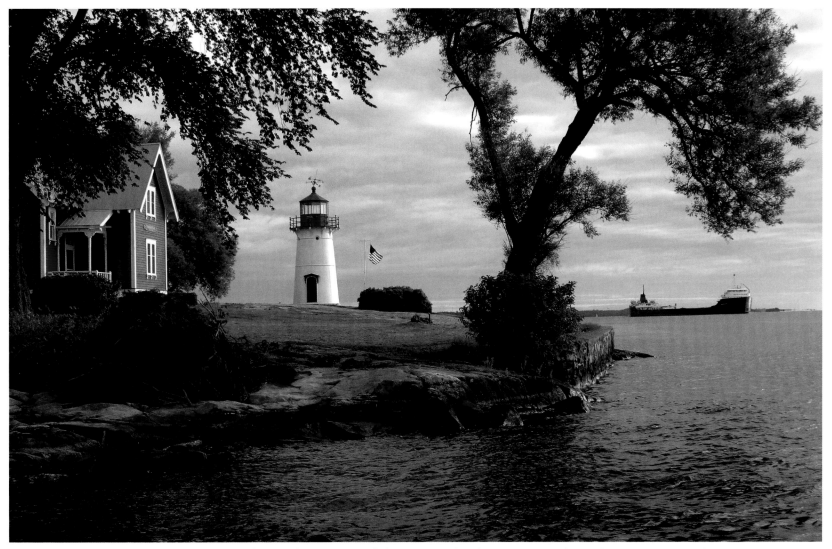

Built in 1848, Crossover Light marks a series of dangerous shoals at a point where the St. Lawrence Seaway shipping channel crosses over from the American to the Canadian side of the river.

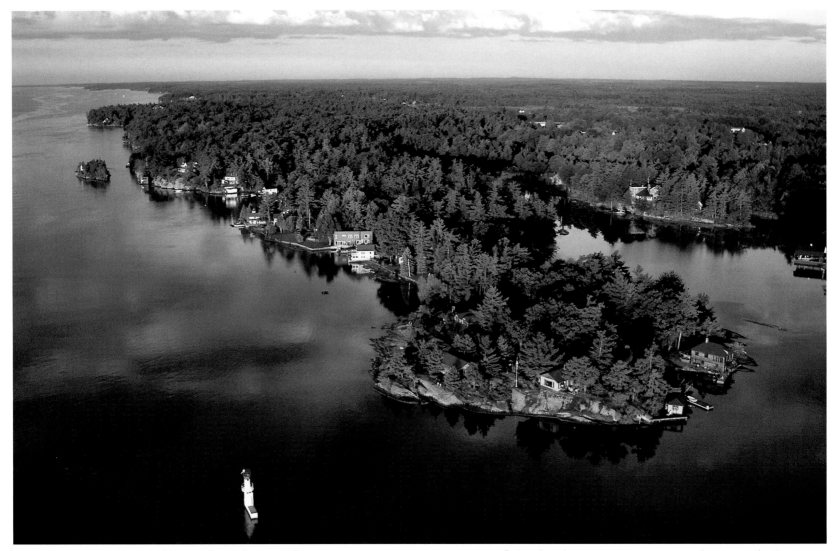

On June 26, 1930, the residents here in the Victorian cottage community of Fernbank were witnesses to a huge explosion. Carrying a cargo of dynamite, the J. B. King was struck by lightning just across the Brockville Narrows.

Except for sheltered areas, the river is seldom completely calm. The current, gentle breezes, ships, boats, even fish jumping and waterfowl swimming all constantly conspire against it.

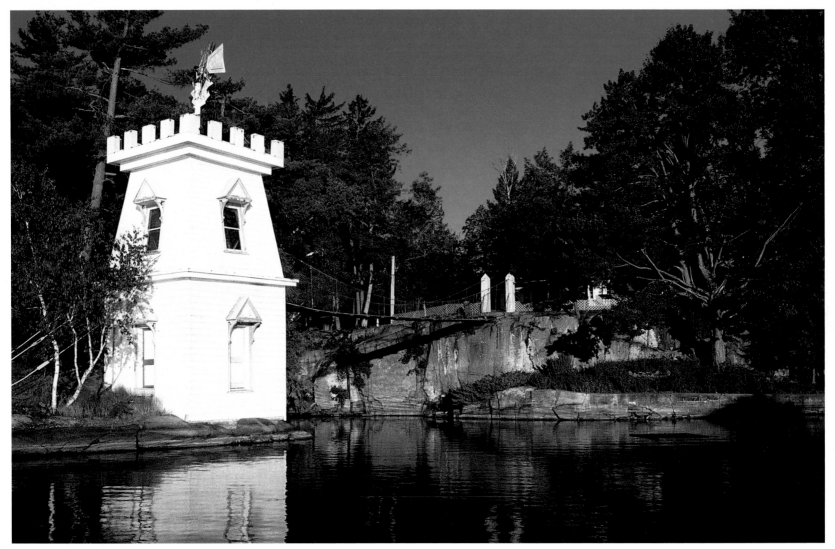

Along the Brockville Narrows, much of the river's shoreline consists of cliffs of varying heights. This suspension bridge to a windmill and its interior staircase is one of many ingenious solutions to gain access to the water.

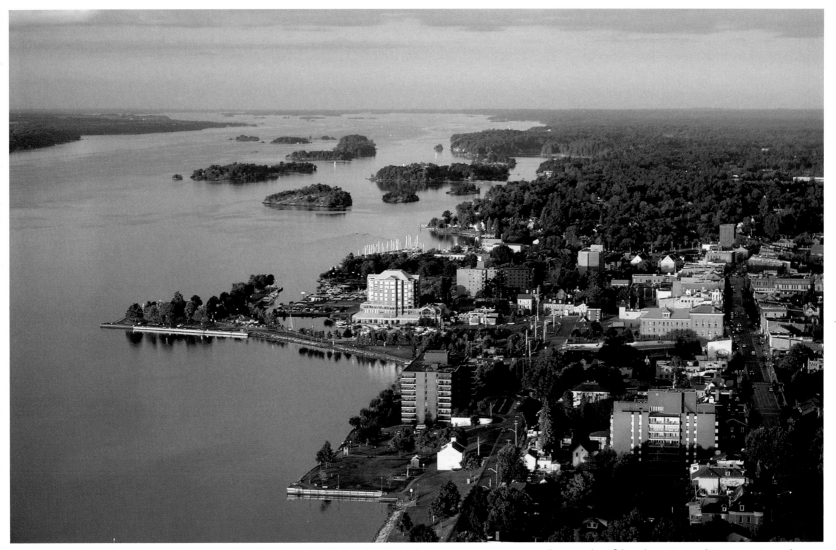

Repaying their loyalty and losses after fleeing the U.S., the British government granted parcels of land to United Empire Loyalists along the Canadian side of the river, including here in Brockville, following the American Revolution in 1776.

There are many wonderful places where you can sit and relax to soak up the beauty of the 1000 Islands.
Some add a beauty all their own.